ARAH WHITING

BEYOND

Literalism, Sensibilities, and Constituencies in the Work of James Carpenter

SURFACE

APPEAL

HARVARD UNIVERSITY GRADUATE SCHOOL OF DESIGN

CAMBRIDGE, MASSACHUSETTS

ISBN 978-1-934510-17-9

Editorial and production assistance by Ben Colebrook, Jared James May
Designed by Matthew Monk
Printed and bound by Meridian Printing, East Greenwich, RI
Distributed by Harvard University Press

Cover image: detail from James Carpenter, Moiré Stair Tower,
photograph by Andreas Keller

The Harvard University Graduate School of Design is a leading
center for education, information, and technical expertise on the built
environment. Its departments of Architecture, Landscape Architecture,
and Urban Planning and Design offer masters and doctoral degree
programs and provide the foundation for its Advanced Studies and
Executive Education programs.

CONTENTS

James Carpenter brings art, technology, and poetry into the field of architecture by means of an obstinate and intense dedication to the investigation of the phenomenon of light and the use of glass. The nature and qualities of light have engaged man's curiosity and generated delight continuously since antiquity. Late antiquity thinkers such as Plotinus made it the subject of the most sophisticated philosophical speculations. Byzantine art and architecture provided us with some of the earliest and still strongest demonstrations of light as a building material, a material that could be manipulated and effectively used in the shaping and transformation of space.

As the embodiment of positive attributes such as clarity, enlightenment, wisdom, strength, purity, truth, liberation, salvation, birth, glory, and apotheosis—just to name a few—light is the unspoken companion of our good architectural experiences. The vehicle of choice in articulating, calibrating, and controlling the wondrous yet precise effects of light is glass—glass in its various states and potentials: opaque, colored, transparent, translucent, reflective.

James Carpenter has chosen glass and its elusive properties as a field of investigation. He has distinguished himself as a master in its development and use in art and architectural projects. As the partner of choice of prominent architects, the recipient of innumerable awards, and a unique thinker on this subject for more than twenty-five years, he has made his mark as a designer, researcher, and artist by propelling our understanding of light and the potentials of glass not only as a vehicle of light but as a true structural component to new frontiers of experience, pleasure, and performance.

For me, the most fascinating thing is how light can be redistributed
or reorganized and thus reveal itself in different ways…Lots of people
are trying to create the lightest and most transparent glass walls.
What happens, though, is that the glass disappears, and the structure
itself becomes the dominant visual element. We are working from
a different direction. We want the glass to have a material presence.[1]

—JAMES CARPENTER

The appearance of architectural neomodernism, a more pervasive attention
to tectonic detail and materiality, and a revived interest in phenomenology
coincided smoothly in the 1980s with the maturation, proliferation, and
commercialization of minimalism. In light of this confluence, it would be
easy to assume that the work of James Carpenter, with its technical preci-
sion and luminous effects, should be categorized somewhere in this camp
of neominimalist-neomodernism: illustrative of a trend and even recog-
nized as the best of this trend with such national accolades as the MacAr-
thur Fellowship. It is important, however, to remember that the MacArthurs
are not the Oscars: rather than stamping someone with the seal of confor-
mity, the MacArthurs recognize individual originality. Carpenter's original-
ity lies in how his work flirts with the general institutionalization of
minimalism and modernism that took place (particularly in the American
context) during the 1980s, but his projects ultimately swerve away from
this trend to construct his own world apart—a world where light is made
material and surface is not celebrated for its immediacy but is a ticket to
something else, something beyond. What you see isn't all you get: there's
more to the story.

 This book's two essays and a set of original diagrams consider the
parameters of the "something beyond" in James Carpenter's projects.
Architectural historian Mark Linder offers a long view of Carpenter's work,

putting his early career as an installation artist and experimental filmmaker in the context of contemporary art practices. Linder draws out the continuities between this early work and Carpenter's current practice as a glass designer, demonstrating a consistent focus on literalism—materiality, spatial perception, and inhabitation—as opposed to phenomenological effect, expression, and representation. My essay examines the sensibilities and constituencies that emerge from Carpenter's practice. Rather than succumbing to the technique of Brechtian estrangement, which has become a default strategy for avant-garde practices in all domains, Carpenter gently eases his viewers into new constituencies. Perceptions and publics are altered, although these alterations are never dictated. Carpenter's new worlds are not avant-garde but are more like dreams that embed themselves in the back of one's mind, opening new possibilities without choreographing what those might be. Finally, Lucia Allais's diagrams offer a visual means of reading Carpenter's combination of technique and effect—his means of *making light material* and *making material present*. Photographs and extended captions from Carpenter himself complete this book's documentation of key projects.[2]

The projects featured in this book are far from comprehensive; each was selected because it especially extends beyond the surface to offer profound possibilities.[3]

NOTES

1. Interview with Frank Kaltenbach, *Detail* (2000: 3): p. 345.

2. Thank you to Ben Colebrook of James Carpenter Design Associates for his invaluable assistance.

3. For a complete retrospective on Carpenter's work, see Sandro Marpillero, *James Carpenter: Environmental Refractions* (Basel: Birkhauser, 2006).

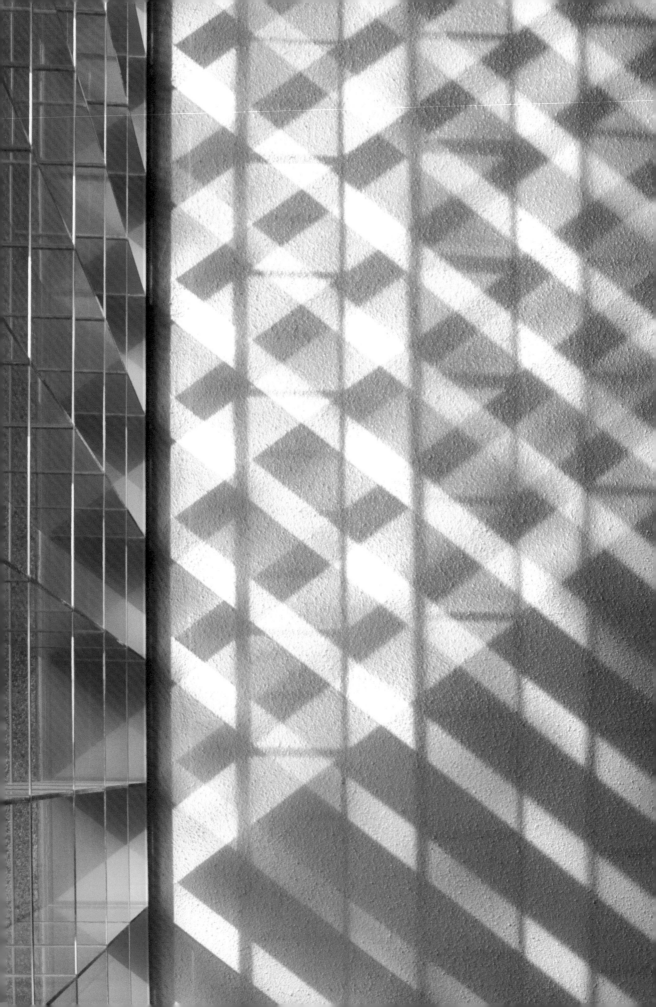

ARCHITECTURE, MORE OR LESS

We are in that area bounded by architecture, engineering, and art,
but we are not really operating in any of those disciplines specifically.
—JAMES CARPENTER

Only an art can define its media. A modernist art, investigating its
own physical basis, searching out its own conditions of existence,
rediscovers the fact that its existence as an art is not physically assured.
—STANLEY CAVELL

It is impossible to know whether the built work of James Carpenter is in
fact architecture. His structures are among today's most advanced and
innovative applications of glass as a building material, yet they are most
often commissioned by (licensed) architects as highly particular installa-
tions in much larger buildings. So, strictly speaking, Carpenter's work is
something less than architecture. But it is also often more sophisticated
in its spatial effects and technical means than the buildings for which it is
designed. In his role as a consultant Carpenter demonstrates possibilities
for building and contributes a range of effects and techniques to archi-
tecture that likely would not be achieved by working strictly within the
discipline. If Leon Krier could claim that because he was an architect he
was unable to build—in a culture that builds too poorly and too much—
Carpenter exemplifies an entirely different paradox: he is *not* an architect
because he builds too well and too little.[1]

One way to wiggle out of this predicament is to call Carpenter an artist,
which would not be entirely misguided, although it would be seriously mis-
leading. Carpenter's work does seem more like art than architecture but
that tells us more about conceptual limitations than disciplinary limits.
Any confusion is less a matter of proper categorization than a result of

Carpenter's own complex development as a designer. He briefly studied architecture at RISD in the late 1960s, then became involved in that school's nascent glassmaking program, and ultimately received a degree in sculpture, although most of his work was closer to film and photography. After graduating, Carpenter intermittently and simultaneously produced experimental films and investigated glass technology, working as both an installation artist and a research consultant to Corning Glass on projects to develop photosensitive glass products. In this way, in his education and throughout the 1970s, the transdisciplinary field in which Carpenter worked was comprised of the same interests and expertise that he would later combine *as* architecture—or something more or less like it—when he

right: Larry Bell, *Untitled* (1969); *facing page*: Larry Bell, *Standing Wall Installation* (1972)

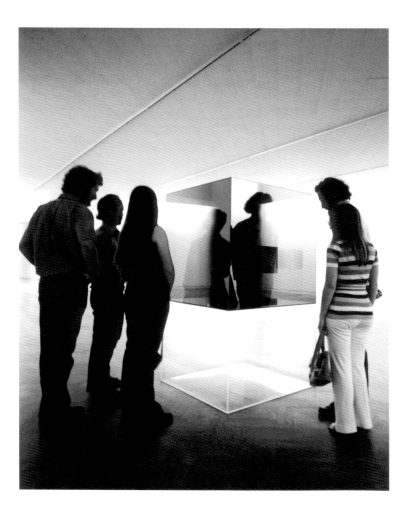

founded his design studio in 1979. That turn toward, or return to, architecture reveals affinities with artists such as Larry Bell and Dan Graham but was provoked by his dissatisfaction with other more pervasive trends in the art world. As interest in conceptual art began to give way to "postmodern" concerns with expression, textuality, and representation, Carpenter believed that architecture would allow him to continue to investigate, construct, and deploy the cinematic effects and material potential of glass that he had explored in his film installations and technical research.

Carpenter's move toward direct engagement with the production of architecture also promised a more general audience for his work, but it came at a price. While his artwork was conceived as an inquiry into image,

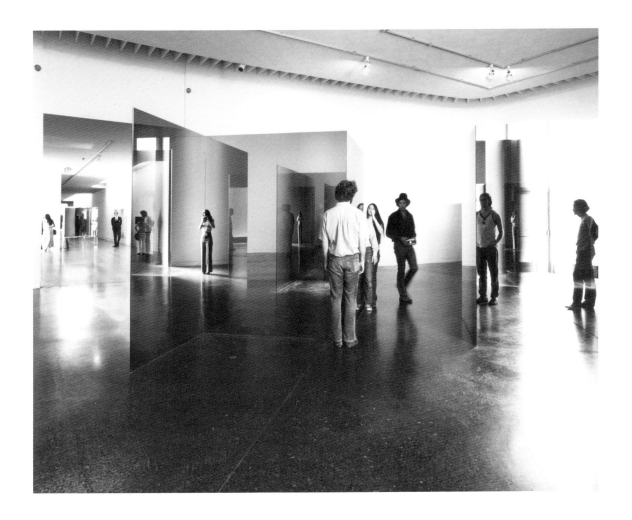

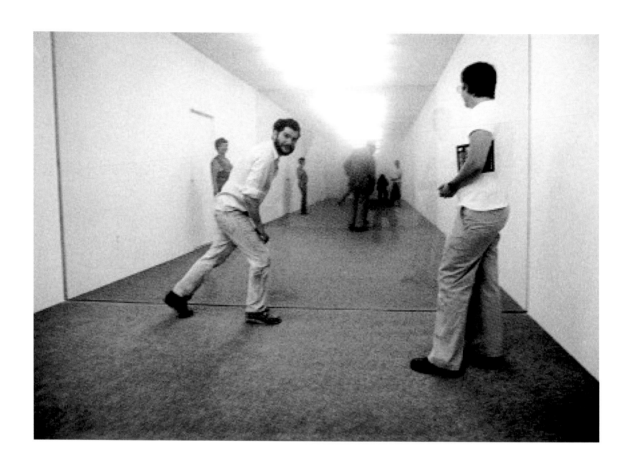

Dan Graham, *Public Space/Two Audiences*
(1976)

material, surface, light, time, and the appearance of nature, those same interests—and the formal and technical devices he used to explore them—become nearly unnoticeable, or largely overlooked, when deployed as architecture. Certainly Carpenter's installations and film projects of the 1970s were already architectural. This was as much a result of his own background as the art world context within which he worked. Perhaps the greatest legacy of the art practices of the 1960s (minimalism, conceptual art, happenings) and the 1970s (performance, land art, installations) was a recuperation of architecture's potential to inform and influence art. This "architectural turn" in the art world was one of the strongest reactions against "modernist" medium specificity and the pictorial modes of visuality advocated by prominent critics such as Clement Greenberg and Michael Fried. Minimalism and conceptual art initiated, and continue to exemplify,

art practices that depend on *literal* relationships to the architectural spaces in which they appear (even if that dependence sometimes manifests itself as a refusal to be contained in the "white cube" of the gallery). This literalist position initially emerged as a rejection of modernist painting, as it had been defined by a continuous tradition of pictorial formalist criticism that began early in the twentieth century with Roger Fry's essays on postimpressionism, continued in Greenberg's essays of the 1940s and 1950s, and culminated in Fried's revision of Greenberg in the 1960s.

The most innovative counterarguments to pictorial formalism emerged in the mid-1960s, when artists such as Mel Bochner, Robert Smithson, Robert Morris, and Claes Oldenburg engaged architectural concerns and conventions such as spatial perception and representation, inhabitation, scale, fabrication, and the room as container. In the years that followed, a myriad of art practices emerged in the art world, each with particular and canny uses of architecture. The intrigue of this context becomes yet more complex for someone working between art and architecture because, curiously, in the 1960s and into the 1970s, when many artists engaged architecture as a means to resist what Duchamp so wryly termed "retinal art," many prominent architects were enthusiastically codifying pictorial design techniques derived from cubist painting and gestalt psychology.

Seen against that background, Carpenter's return to architecture in the late 1970s was not a simple decision to abandon the art world for a more public realm of operation. Rather, Carpenter's architectural work reconfigures the same spatial tactics and technical means he had applied as installation art. But it entailed an inversion of his priorities and disciplinary identities. This was enabled not only by his background, but also indirectly by the emergence of literalist art and the transdisciplinary practices it inspired. Carpenter was one of the first to realize, and exploit, the potential of that discursive shift by proposing that architecture not only can serve as the site and setting for literalist operations, but that the discipline of architecture is itself a site and setting within which to enact literalism.

Like the well-known projects of artists such as Vito Acconci, Glen Seator, Andrea Zittel, Jorge Pardo, and others working after literalism, Carpenter's glass structures remain between the discourses of art and

architecture. They are productive operations in the space between disciplines that interrogate the conventional limits of architectural knowledge. None of his projects better represents the complexities and potential of this condition than one of his simplest. In the Rachofsky residence, designed by Richard Meier for a Dallas art collector, Carpenter was asked to devise a glass screen that could be retracted into the floor between the display and living areas of the building. On the one hand, the project is nothing more than a removable wall that functions to distinguish the house's two distinct programs: gallery and residence. On the other hand, the project is nothing less than a piece in the owner's art collection, which includes, notably, a fine example of Jo Baer's proto-literalist white canvases. Baer's diptych hangs adjacent to the glass partition and interacts in nuanced ways with its formal and visual effects.

But the wall also enacts a more general exchange between gallery and house, art and architecture. When the glass wall is in storage, the house becomes more residential (the gallery is simply another room); when the glass wall is on display; the house becomes, in effect, more architectural (the screen produces ambiguities between contents and container, art space and living space). This is the case despite the fact that the glass structure, or screen, is a useless element of the architecture of the gallery: though it seems to be a wall, it is not usable for hanging pictures, and though it is glass, it is not a window. Its only function is to distinguish between the gallery and the dining area of the residence. Through extraordinary construction techniques and visual effects it denies rather than enables function (which makes it *deeply* architectural and *hardly* aesthetic). It is neither quite useless nor useful, and it is not quite an artwork or a work of architecture. Instead it becomes more of both by conjoining the two through appearances of complicity. The screen increases the artworks' capacity to literally engage the architecture, and vice versa. Two different glass surfaces—clear and reflective on the gallery side, frosted by acid etching on the dining room side—produce divergent effects: openness and enclosure, mirroring and absorption. Glass, in this case, is at once the most visible and indivisible part of the house. It is not simply transparent like any of the house's large glass windows, but an architectural element—as well as a signifying object and a theatrical device—that makes its appearance difficult to identify.

Glass is the only material in the building industry which expresses surface-and-space at the same time.... It satisfies what we need as contemporary designers and builders: an inclosure that is space in itself, an inclosure that divides and at the same time links.

—FREDERICK KIESLER

Carpenter's work should not be understood in phenomenal terms. First, the glass wall is not a mechanical instrument that presents the reality of subjective experience, but a technological device that registers reality in terms of ambient information. Second, to understand projects such as the Rachofsky screen as primarily experiential—heightening our awareness of reflections, colors, and materiality—obscures the ways in which all of Carpenter's work is a technical intervention in architecture's particular assimilation of the pictorial traditions of modernism. Carpenter's projects are better understood as architectural translations of the monochrome canvas, and extensions of its implicit reconfiguration of the relationship between art and architecture. When it emerged in the 1950s and 1960s, the monochrome canvas initiated a critique of a 500-year tradition in painting that posited pictorial art in terms of transparency and projection: as a window in a wall. This trope, which was first articulated by Alberti in *On Painting* (1436), established architecture as the frame and setting not only for painting but for all visual art. But in the twentieth century the relationship between painting and architecture became so strained theoretically that for modernist critics such as Greenberg or Fried, the proper experience of visual art, and the extension of the Western tradition of painting, required the virtual absence, even the implicit denial, of architecture.[2] According to Greenberg, modernist painting should be conceived in the specific terms of its medium—as reducible to "the flat surface, the shape of the support, [and] the properties of pigment"[3] and should be perceived as "kind of picture that, without actually becoming identified with the wall like a mural, would spread over it"—thus overtaking architecture's physicality and spatiality with a pure pictorialism.[4] A monochrome canvas, such as Baer's, with its emphasis on objecthood, was not only a reaction against the inherent immateriality and autonomy of pictorial art; it also was a precursor to the literalist recovery of architecture as the site and setting for encounters with artworks.

Carpenter's glass wall extends the critique of pictorialism and recuperates the potential of other, more literal, relationships between architecture and recent painting. It cannot be understood in terms of pure transparency or as a picture plane. Instead it emphasizes its structural integrity and—ironically—the impure opacity of its glass surface. As both an object and an image, Carpenter's glass wall—like the monochrome canvas—is a direct challenge to the boundaries that separate architecture, painting, and sculpture, as well as to the autonomy of the art object. Like the work of painters such as Baer, Frank Stella, Agnes Martin, Brice Marden, or Robert Ryman in the 1960s, Carpenter's glass wall proposes that vision is a matter of looking at, not seeing through, a surface. Carpenter's use of glass appears to be most like the nearly invisible work of Agnes Martin. Both Carpenter and Martin are intense observers of natural light, and each has developed highly technical means for the production of extremely subtle, and seemingly natural, visual effects. But a more direct relationship can be drawn with Robert Rauschenberg's White Paintings of 1951. In a letter to Betty Parsons pleading with her to exhibit them, the young Rauschenberg explained that their surfaces were to be continuously freshened with coats of flat white paint that could serve as a "landing strip" for light, dust, and shadow. In Dallas, the material is glass rather than canvas, which is stacked rather than stretched, and a fresh coat of Windex has replaced white paint, yet Carpenter and Rauschenberg harbor similarly literal motives for gathering spatial information. They also deploy similarly sly inversions of material techniques. The tensile structure of Carpenter's wall emphasizes both the weight and compressive capacity of the seemingly light and brittle glass. Like Rauschenberg, who produced a dense surface with a common, light, stretched, and opaque material, Carpenter produces a tense surface with a refined, heavy, compressed, and transparent material.

Carpenter's glass structure is not a picture, a window, or a wall, but a screen. As his background suggests, his glass structures might be understood not only in architectural and (anti)pictorial terms but also in relation to film. We might even say that Carpenter works in (and between) three disciplines, or mediums: architecture, painting, and film. One source that provides some insight into the difficulties and potential of this

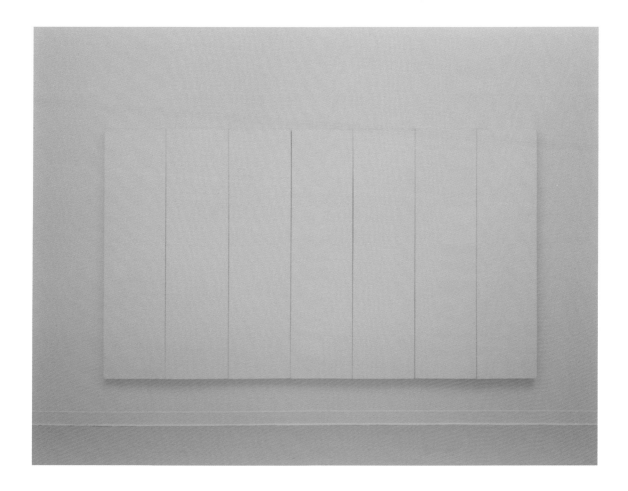

combination is Stanley Cavell's short but dense 1971 book, *The World Viewed*, in which he attempts to define the medium of film in relation to modernist painting.[5] One conclusion that can be drawn from Cavell's discussion (although he studiously avoids this claim) is that such comparisons—and projects that aspire to provoke such comparisons—exemplify the modernist condition. For Cavell, "the task of the modernist artist" is "one of creating not a new instance of his art but a new medium in it" (104). Further, when "an art explores its medium, it is exploring the conditions of its existence; it is asking exactly whether, and under what conditions, it can survive" (72). Cavell, following his friend Michael Fried, presumed that a new medium must emerge *within* a particular discipline.[6] He dismisses the possibility of transdisciplinary modernist works. Yet the attempt to come *to terms with* one medium *in terms of* another medium is precisely how Cavell approaches film, and his "philosophical criticism" provides a model for the sort of transdisciplinary practice that (in the contemporary situation) is one way for an art to survive.[7] Following Cavell's logic, it is possible to understand the trajectory of Carpenter's career as an ongoing concern with the survival of architecture that has involved engagements with film, sculpture, glass research, and installation art. The

Robert Rauschenberg, *White Painting [seven panel]* (1951)

Labels in image:
"ONE-WAY" MIRROR
CANVAS CEILING WITH FLUORESCENT LIGHTS
TRANSPARENT SURFACE
THIS ROOM IS UNLIGHTED AND DIM
MIRROR SURFACE
THIS ROOM IS VERY BRIGHT
MIRROR
CAMERA
WITH VIEWFINDER
ON TOP; LENS IS
AGAINST GLASS
MONITOR
SHOWS SPECTATOR
IN ROOM B AS HE IS
OBSERVED FROM ROOM B
ROOM A
ROOM B

Dan Graham, *Two Viewing Rooms* (1975)

particular path Carpenter has taken is important not as a general model for architects, but because it provides the means to understand the new medium he has devised for architecture.

What happens to reality when it is projected and screened? ... It is as though the world's projection explains our forms of unknownness and of our inability to know. The explanation is not so much that the world is passing us by as that we are displaced from our natural habitation within it, placed at a distance from it. The screen overcomes our fixed distance; it makes displacement appear as our natural condition.
—STANLEY CAVELL

Cavell quotes Erwin Panofsky on the medium of film being "reality as such." This is so because of its basis in photography. Film's engagement with reality, Cavell suggests, is both automatic (due to mechanical reproduction) and displaced (because images of reality are projected and screened). In Dallas, Carpenter enacts a seemingly filmic engagement with reality, but in that case it is enacted as a collaboration between art and architecture. Still, it is also helpful to understand how Carpenter comes to terms with architecture in terms of film and, in turn, how the work reveals certain differences between each medium's engagement with "reality." Today, architectural "reality." Typically architectural reality is characterized in terms of function, tectonics, or culture ("the everyday" or "the public realm") and while the glass wall, like all architecture, could be explained in those terms, its "realism" is better understood in terms of film. Carpenter's project is a device for the projection and screening of the facts, effects, and signs of the space it not only occupies but also produces

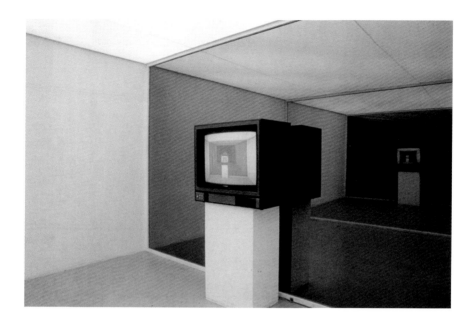

through displacement. The glass surface, enabled by the tensile structure that stabilizes it, displaces the architecture and its space by taking the medium of architecture to be screened superficial space.

There is an important similarity between screening and the monochrome canvas, one that distinguishes both from pictorialist art. Again, Cavell offers some precision and insight. The "reality" of pictorial art ends at its frame (i.e., the metaphorical border between window and wall, or art and architecture). Quite simply, the edge of a painting marks the limits of its world. Films and photographs, however, are not framed but cropped.[8] So the world of a painting is limited, while the world of a photograph, or film, or object (like a monochrome canvas) is not. "You can always ask, pointing to an object in a photograph—a building, say—what lies behind it, totally obscured by it. This only accidentally makes sense when asked of an object in a painting. You can always ask, of an area photographed, what lies adjacent to that area, beyond the frame" (23). That is definitively untrue of pictorial art that is "totally there, wholly open to you, absolutely in front of your eyes, as no other form of art is."[9] As a consequence, Cavell claims, pictorial art is "a denial of (physical) spatiality [which] is not *all* there to the eyes" (109).

The monochrome canvas and film, like architecture, have a stake in countering that denial. What Carpenter's work appears to do is to bring all three mediums together, a spatial possibility that derives in crucial ways from his earlier film projects. One of his first films, titled *Cause*, done while still a student at RISD, introduces the problematic of screening and architecture. A camera was mounted directly above a square white table as if viewing it in plan. It recorded the activities and objects that occupied that surface, in this case a pair of hands cutting a loaf of bread and feeding

Dan Graham, *Two Viewing Rooms* (1975)

it to a crow, which flies in and out of the picture. When the film was shown in a gallery, the same table was used as a screen. The projector was mounted in the position where the camera had been and the film was cropped to the shape of the table, allowing the viewer to see the hands, bread, and bird projected as a horizontal image on the actual surface where their interaction had occurred. The displacement in this case is both spatial and temporal. The viewer encounters the same site as the filmed objects—the table—but sees the record activities projected and screened from an inaccessible viewpoint. The architecture remains more or less the same but the contents of the space, including the table itself, have been changed by the screened image. The table becomes simultaneously an object and a screen.

Surprisingly, *Cause* exemplifies Leo Steinberg's famous notion of the flatbed picture plane.[10] Writing in 1972 about another kind of photographic screening, Steinberg argued that artists such as Robert Rauschenberg who use printing processes such as silk-screening had reconceptualized the "painted surface [as] no longer the analogue of a visual experience of nature but of operational processes" (84). The fact that those works are produced in a horizontal position is crucial, but ultimately for Steinberg the difference between the flatbed picture plane and pictorial art is a question of reality: "The flatbed picture plane makes its symbolic allusion to hard surfaces such as tabletops, studio floors, charts, bulletin boards—any receptor surface on which objects are scattered, on which data is entered, on which information may be received" (84). Steinberg suggests that the flatbed "let the world in again. Not the world of the Renaissance man who looked for his weather clues out the window; but the world of men who turn knobs to hear a taped message, 'precipitation probability ten percent tonight,' electronically transmitted from some windowless booth" (90).

Carpenter's projects are radically literal versions of Steinberg's flatbed: the film projects and glass structures are not "symbolic allusions to hard surfaces" but literal illusions produced on and with hard surfaces. In his early film projects, Carpenter's "windowless booth" was an art gallery absent any pictorial works. While it would seem that those early film projects are concerned with the representation of nature, their ultimate effect

is to abstract and denature spatial experience. The reality they screen is not simply "nature" but information that is reconfigured through technological processes and devices. The development of that approach can be traced in three projects that all involved filming live fish, with each requiring increasingly complex and potentially architectural technical means. In the project, *Tails of Fate*, Carpenter filmed the moving fins of salmon through the side of a large aquarium in a research laboratory. When the film is projected, it is unclear whether the image is of the rhythmic motion of the fish, the flow of the slightly cloudy water, the refractions produced by the water's surface, or the reflections on the tank's glass surface. The film begs the question of *what* is being filmed.

The subsequent project, *Migration*, was a much more complex endeavor to film wild salmon in a shallow river. A series of scaffolds were constructed above the water, each holding a camera aimed downward, so that as the fish moved upstream they would pass from the view of one camera to the next, which included not only the water and the river bottom but also an inconspicuous reflection of the sky above. When shown, the films were projected on the gallery floor in the same sequence (but with each film frame repeated three times to produce a delayed strobe effect). Though the architectonic structure of the scaffolding disappears in the images, it is transferred to the space of the gallery and the projection apparatus, as well as, more conceptually, to the temporal spacing between the strobotic image and "real" time. When viewed, the images are thus less about fish than about the literal and virtual indeterminacies of a space (the river or the gallery) and a surface (the sky/water or the image/floor). The fish are decoys, or dummies, that appear though the screen of the water's surface to reveal space, but not architectural space in anything like a conventional or phenomenal sense.

In *Koi*, the third fish project, literal structure returns explicitly to the installation. With a camera once again mounted vertically, a single camera filmed patterned carp known as koi swimming slowly among lily pads in a Japanese garden, their dorsal fins slicing the water's surface and intermittently disappearing as they pass beneath lily pads. That image was then restructured by cropping it into nine separate images, which together form a nine-square grid. When projected, each square is slightly out of

sync with the others, creating an effect not unlike the panes of a window in which the glass is out of alignment, cracked, and stained. But it is a window that one looks at, not through. The projected image accentuates this appearance of flatness and opacity. One sees the fish under the water, but its surface, which was already elusive—dulled by the vague reflection of the gray sky above—becomes even more so. The koi seem to cut the screen with their bodies, while the lily pads float like opaque figures blocking any view of the water's surface, its contents, or its reflections. Those three "materials"—fish, plants, water—accentuated by restructuring and temporal manipulation, establish the visual and informational range of the screened image.

The technical means and visual effects of Carpenter's films establish the terms by which his recent work with glass structures realizes—in ways unimaginable to Greenberg, Fried, or Steinberg—one version of the architectural possibilities latent in the recent history of art. Those relationships are especially clear in his *Periscope Window*, which integrates the technical means of film—multiple images captured and manipulated by lenses, mirrors, filters, and finally their screening—into a single 12-inch-thick optical device. Time, displacement, surface, reflection, image, and denaturing are all discernable when one looks at its surface. Like all of Carpenter's work, *Periscope Window* demonstrates Cavell's claim that the "'possibility' of a medium can be made known only by successful works that define its media; ... a medium is explored by discovering possibilities that declare its necessary conditions, its limits" (146). Carpenter's "architecture," like Cavell's "philosophy," works at and on those necessarily fluid limits, remaking and displacing them. The result is a denatured discipline: architecture, more or less.

NOTES

1. See Leon Krier, *Drawings 1967–1980* (Brussels: Archives d'Architecture Moderne, 1980), p.82.

2. This claim is elaborated in Mark Linder, *Nothing Less Than Literal: Architecture after Minimalism* (Cambridge, MA: MIT Press, 2005).

3. Clement Greenberg, "Modernist Painting," *Arts Yearbook* 4 (1961): 103.

4. Clement Greenberg, "The Situation at the Moment," *Partisan Review* 15 (January 1948): 83. In 1958, Greenberg would extend this notion of pictorialism to sculpture. "Under the modernist 'reduction' sculpture has turned out to be almost as exclusively visual in its essence as painting itself.... The human body is no longer postulated as the agent of space in either pictorial or sculptural art; now it is eyesight alone, and eyesight has more freedom of movement and invention within three dimensions than within two." Clement Greenberg, "Sculpture in Our Time," *Arts Magazine* 32 (June 1958): 23.

5. Stanley Cavell, *The World Viewed: Reflections on the Ontology of Film* (New York: Viking Press, 1971).

6. Cavell not only followed his friend Michael Fried in subscribing to medium specificity, he adopts without reservation and repeats Fried's *judgments* of contemporary painting. Yet Cavell exceeds Fried's *conceptualization* of modernist art and his theorization of the notion of medium. Cavell's notion of medium derives from speculations on music, theater, and film as well as painting, and his approach seems to leave room for the possibility that one medium, in order to survive, might swerve from its traditional center by adapting devices and motives from other mediums (despite his repetition of Fried's rejection of that possibility).

7. Cavell describes his own and Fried's approach as philosophical criticism in "Aesthetic Problems of Modern Philosophy," in *Philosophy in America*, Max Black, ed. (Ithaca: Cornell University Press, 1965), pp. 85–86, and "The Avoidance of Love: A Reading of *King Lear*," in *Must We Mean What We Say?* (New York: Charles Scribner's Sons, 1969), p. 333.

8. See note 13 (pp. 162–163) in *The World Viewed* for Cavell's elaboration of these differences.

9. Cavell is reiterating Fried's concept of presentness. See "Art and Objecthood," *Artforum* (Summer 1967): 12–23.

10. Leo Steinberg, "Other Criteria," in *Other Criteria: Confrontations with Twentieth-Century Art* (New York: Oxford University Press, 1972), pp. 55–91.

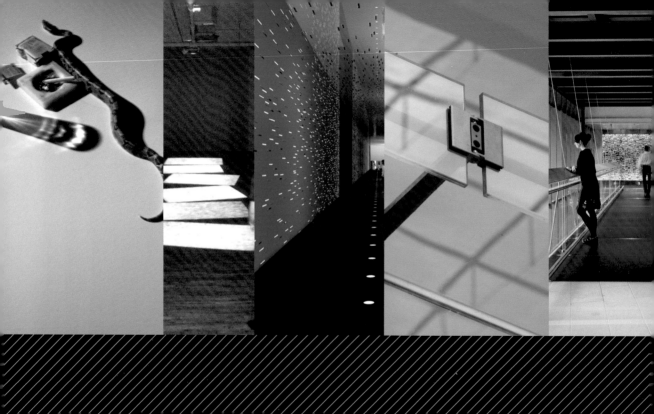

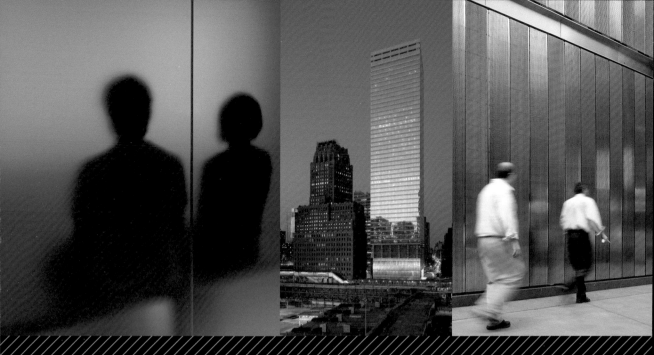

CARPENTER ON CARPENTER

James Carpenter studied architecture and sculpture at the Rhode Island School of Design, graduating in 1972. Carpenter actively exhibited his sculpture and installation film projects in the United States and Europe and worked from 1972 to 1982 as a consultant with Corning Glass Works in Corning, New York, researching the development of new glass materials, including photo-responsive glasses and various glass ceramics. This research focused on the unique technical capabilities of particular glasses to control and manipulate light and information, which has continued to be the central focus of James Carpenter Design Associates (JCDA), founded in 1978. JCDA is a collaborative studio that fosters an exchange of ideas among architects, material, structural, and environmental engineers, and fabricators.

Recent projects, such as the Israel Museum in Jerusalem, have increased the studio's scale of production, but looking across Carpenter's career, one finds surprising continuities from the earliest film projects through to these more architectural and urban projects. **To reveal these threads, the following section is a transcription of Carpenter talking through a series of particularly significant projects.** His consistent project of light information becomes increasingly evident as he talks across this collection of projects that does not typically receive consideration as a group. —S.W.

My first film projects were **Cause** and **Confines**, which were done on table-top surfaces. These were an attempt to find new ways to present a body of information or a sequence of events. Until this point my work was done exclusively using glass: I was working with photographic emulsion on glass, printing photographs on large glass sheets, producing large-scale negatives and projecting them onto glass, as well as projecting films against glass surfaces. With all of this work, I saw the glass as a substrate holding multiple fields of information. Once I started projecting film onto glass, I realized that the glass wasn't necessarily required to activate a surface or a space. I think the first films were a little more didactic in that they were literally trying to reclaim a moment in time and space. In the case of **Cause** and **Confines**, this meant

Cause, 1975–1976; Super-8 film loop;
View of projection in gallery installation
Shown in 1978 at the John Gibson Gallery,
New York, New York

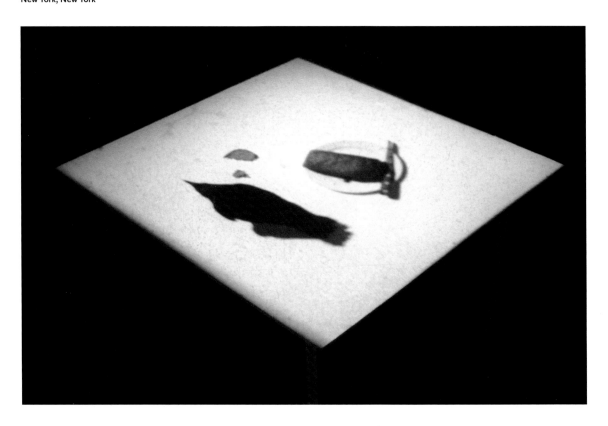

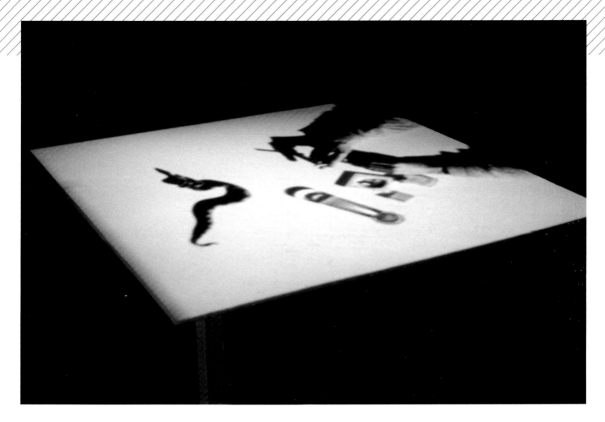

Confines, 1975; Super-8 film loop;
View of projection in gallery installation
Shown in 1978 at the John Gibson Gallery,
New York, New York

treating the table surface as a stage, recording the events happening there in real time from a viewpoint directly over the table, and then projecting those events back onto that same table's surface. So we aren't talking about a film with a conventional narrative, but rather the activation of objects. Through this lens I was already thinking about architectural space where you might take a space, film its parts, and actually selectively reconstruct that space by projecting those fragments on walls, floor, and ceiling to activate the salient aspects of a deconstructed three-dimensional space.

When you look at projected film, it reveals its chemical composition—the color of the grains of the film that make up the emulsion's chemistry. There is something incredibly organic about film. As light passes through those photosensitive crystalline structures, it almost becomes tangible. It had a lot to do with film being able to activate a space the same way that daylight activates a room through shadow

and direct light over time. In fact I was seeing film as a corollary of daylight, though a more content-laden and predictable version of it.

When I think of light as information, I see film as being able to parallel the nature of light—when you pass light through multiple layers of film, that resultant image may be incomprehensible, but the light and composite image are still a total of those recognizable things. I think of light this way. When you find a way to break down the information contained by light, you reveal a much richer world, which is typically inaccessible to us. When you look at a star, you are looking at photons that have traveled for millions of years, so essentially that light is carrying the star's history. You are looking at a moment in time far removed from our "time" but essentially still a contributor to our experience. There is information locked up in the light. It's not purely magnetic waves—light has more to tell us than just about its overt physical properties.

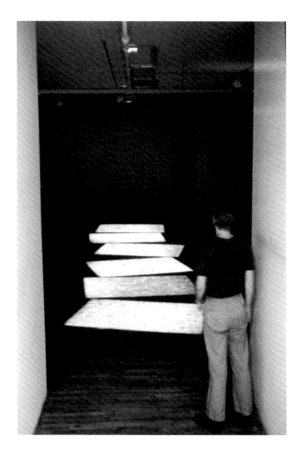

Migration, 1978; Six synchronized Super-8
film loops; Installation view; Shown in 1978
at the John Gibson Gallery, New York,
New York, and at Galerie Nächst St. Stephen,
Vienna, Austria

When filming Migration, my focus shifted away from the activation of objects to capturing large-scale events in nature and projecting them after subtle manipulations that emphasized the perceptual aspect of the experience. In the case of Migration, we shot the original films in 16mm, then printed 8mm prints, holding each frame by printing it three times. It's not really slow-motion—it creates more of a staccato, electric quality. The image is held just slightly longer when you see it projected, which permits your eye to see a greater level of content. As a result, you become very aware of the movements of the rocks on the river bed and the movement of the fish disturbing the surface of the water and the reflections off that same surface. What became striking was the perfectly reflected image of the sky overhead. While filming Migration on site, the sky wasn't something you really *saw* or acknowledged.

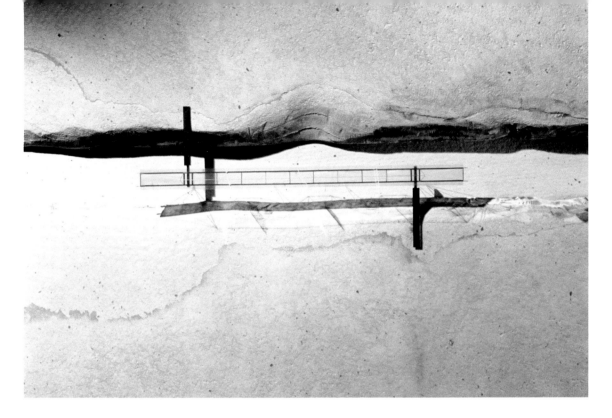

Luminous Glass Bridge, 1987;
Photograph of model

I continued to show the films installations until 1982–1983, both here and abroad, but there was a four- to six-year period between the films being shown and our design of the Luminous Glass Bridge. During the period when I was making films, I was consulting with Corning Glass, where I was working with photosensitive glasses that allowed for the permanent capturing of three-dimensional photo-graphic images in glass, and full-color images in glass, among other things. I think I was consciously moving toward permanent projects that would emphasize the ephemeral qualities that surround us.

When the opportunity to do the Luminous Glass Bridge came up, *Migration* was the clear reference, even though it had been done years earlier. The bridge presented an opportunity to extend the film installation's perceptual experience into the environment from which it came—transposed, of course, into a physical structure. The question became how to synthesize various events occurring in nature while physically placing the observer within those events. *Migration*'s film, projector, and projection surface would be replaced by natural light, water, and glass. Light striking the surface of the water would be reflected back up onto the underside of the bridge—a platform completely made of glass with a diffused upper surface, which is equivalent to the projection plane capturing the caustic surface characteristics of light on water. By orienting the platform to follow the river and supporting this span from walkways cantilevered from each bank, the experience becomes one of walking with or against a naturally projected image of the current. In the same way that you walk into a gallery and pause to observe the work there, the idea of the bridge was to extend the moment of crossing and slow down your passage across the river enough to make you pause and observe the phenomena of light that you are a part of and one's interconnections with the surrounding environment.

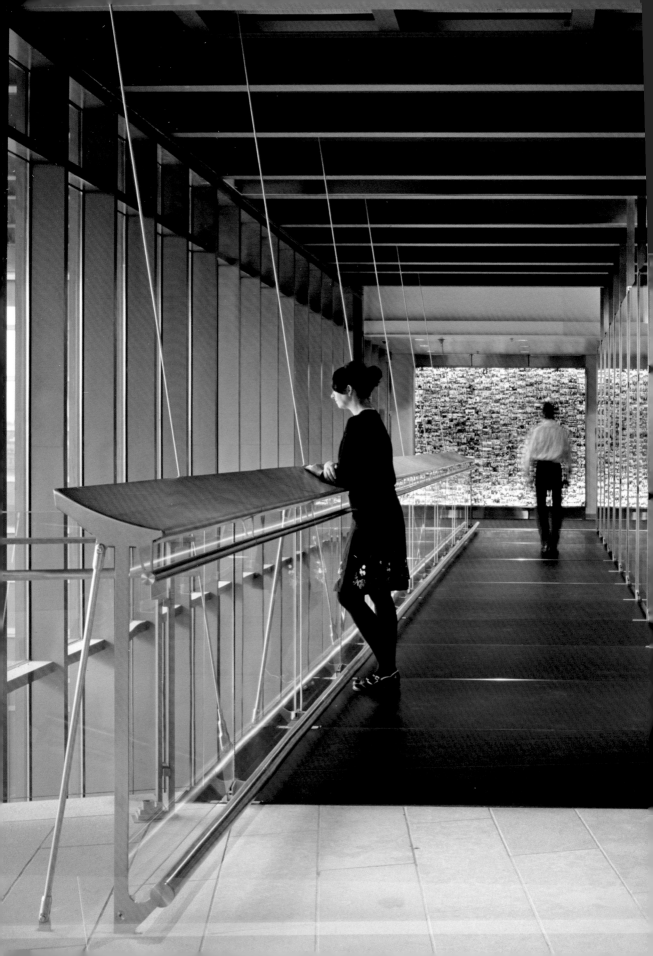

Luminous Blue Glass Bridge, **Seattle, Washington, 2001–2003; View of bridge spanning atrium. Handrail is large enough to lean upon to observe the view of the Puget Sound.**

The Luminous Blue Glass Bridge was built, though it came almost fifteen years after the design of the initial Luminous Glass Bridge. Here again, we were responding to the site. The Seattle City Hall, designed by Peter Bohlin, overlooks the city with a view of Puget Sound in the distance. We were creating a connection between the office tower housing the city's administrative offices and the city hall chambers located across a deep atrium that spills down the hill toward Puget Sound. The idea was to extract the view of Puget Sound in the distance and bring it into the foreground by transposing a blue bar of light/water and floating it across the atrium. As you walk across the bridge to get to the City Hall Chamber, you experience a heightened sense of the Puget Sound.

You walk across a simple piece of floating blue glass, though structurally it is very complex. For thirty years we have been a primary innovator in the use of glass as a compressive material in structures. The whole technical development of our vocabulary has been the result of the need for a clear and simple expression of ideas that can be easily undermined by muscle-bound structures. The basis of our thinking, be it a wall or bridge, is that the structure be sublimated: we would like to see the structure become invisible, while the glass elements, which modernism usually renders invisible, adopt a strong visual presence, revealing the complexity of information within and upon the glass. We are challenging convention in that for us, structure becomes secondary and glass provides the content. For me, that approach has been one of our major contributions to glass practice.

In the unrealized **Dey Street Passage**, the focus was more on the perception of light than a specific phenomenology of light. We determined a limited number of characteristics of light and how they could react to a specific group of materials, few of which were glass. Instead we primarily proposed metals with various qualities of light absorption, scattering, and reflection, which all have to do with the eye's perception of space. The point was to transform the perception and experience of place by expanding the spatial awareness of space through light.

We're known for working with glass and daylight, but the **Dey Street Passage** project had neither. Our projects are not specifically about glass, though glass is often a logical vehicle for manifesting qualities of light. Within the limits of any project, we explore the potential of many families of materials, but consistently seek to expand their potential interaction with light.

The **Lichthof**, designed by Mueller Reimann Architekten, is the main public space of the German Foreign Ministry Office. We wanted this wonderful large-scale outdoor room to represent the openness of the Foreign Ministry to the public. We extended this idea by also tackling the problem of the north-facing courtyard's dearth of daylight.

By working with subtly reflective optical coatings, the receding perspective of the space is extended from the inside into the street, doubling the court-yard's presence and visually linking the **Lichthof** with the park and the historic church across the street. Looking in from the outside, the park is reflected on any part of the cable-net wall that is in shadow, which causes the atrium landscaping to merge with the park. So the project uses a very simple principle of reflectivity and shadow to establish a complex interplay and transposition of surrounding environmental information.

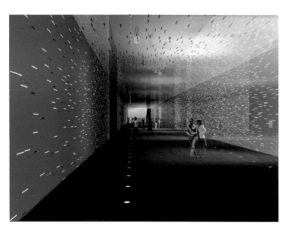

Dey Street Passage, **New York City, 2004;**
Still image from animated rendering

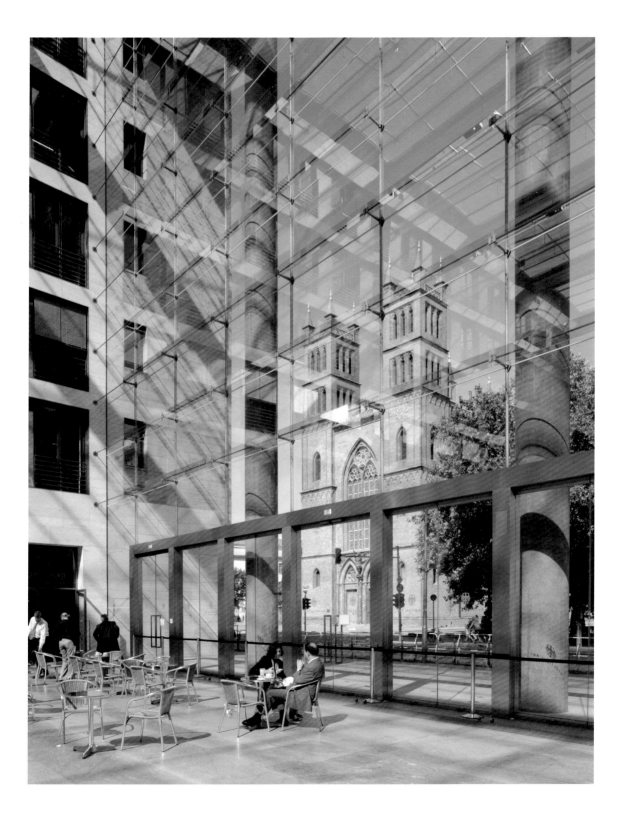

Lichthof, **offset horizontal tension cables supporting ribbons of dichroic glass**

Lichthof, **daylighting reflectors lining the roof support beams**

Working with Transsolar, we incorporated a design detail within the roof beam structure and designed the cable-net wall to transform the spatial experience of light in the courtyard and its connection to the street. We brought the available daylight into the back of the courtyard space using specular daylighting reflectors on the south and north-facing side of the roof beams to illuminate the darkest parts of the courtyard by redirecting daylight and ambient sky brightness. For the cable-net wall, we combined the most transparent glass with a subtle reflective coating. The coating further reflects light coming through the roof back toward the courtyard's shaded area.

Collaborating with Schlaich Bergermann through the structural development of the wall, we integrated ribbons of dichroic-coated glass into the horizontal cable system, offsetting them with stainless steel struts off the interior of the curtain-wall plane. (Dichroic glass contains microlayers of metal oxides, which split visible and invisible light into distinct beams of differing wavelengths.) These ribbons appear blue in transmittance and yellow in reflection, emphasizing the curtain wall's subtle play of transmitted and reflected light. Blue bars of reflected light bring the image of the sky behind you down into the wall surface—transposing the sky image. Essentially the threshold is visually extended by the offset ribbon and its reflection, drawing attention to the wealth of both reflected and transmitted light in the space. We were carefully manipulating the levels of information captured in the different reflective surfaces and concentrating them to elucidate the specific characteristics of that environment.

David Childs's design for the Time Warner complex featured two high-rise towers separated by a building volume occupying the width of 59th Street and containing the public spaces of the development Jazz@Lincoln Center and a large public lobby/atrium. The project maintained the superblock typology usually reserved for public developments like the convention center that once occupied that site. Yet Time Warner is a mostly private development stepping beyond the city's street grid, so the idea was to speak to this issue and perceptually establish 59th Street's passage through the architecture while highlighting the public nature of Jazz@Lincoln Center and the public atrium below.

That's when we proposed the idea of the Double Cable-Net Wall: two singular offset planes of glass that, through the juxtaposition of optimal transparency and reflectivity, extend views through the planes of glass while capturing reflected views of the 59th Street axis on both planes. To achieve this goal, we worked with Schlaich Bergermann to design a structure with a large inclined truss overhead, supporting an inclined acoustical cable-net wall for Jazz@Lincoln Center from its lower interior chord, and then an exterior cable-net wall spanning both the building's atrium and Jazz@Lincoln Center, suspended from the upper chord of the same truss. The interior acoustical wall is inclined to reflect interior sound up to the ceiling while isolating street sounds from the performance space. At the time when this project was built, it was the largest such wall ever constructed. Basically it is the most fundamental, simple, and transparent wall you can achieve.

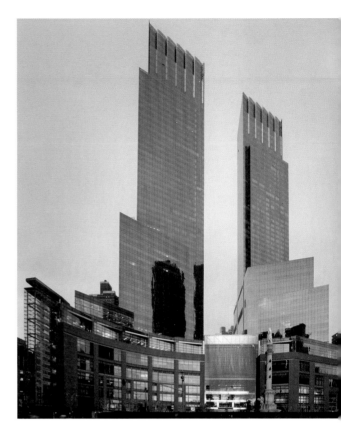

Double Cable-Net Wall, **Time Warner Building**
Jazz@Lincoln Center, New York, 1999–2004;
View of the wall spanning the full width of 59th Street

We worked with Shlaich Bergermann on the Double Cable-Net Wall. Jörg Schlaich is an engineer whose work I admired for many years, primarily for his focus on tensile structures. I also share his interest in simplicity and clarity of structure. I went to see him in the early 1980s when I was starting my design practice and we struck up a friendship, though we didn't have a project to do together until many years later. He pioneered the cable-net structure, and when David Childs of SOM came to us with the opportunity to do the Time Warner entry wall, he was an obvious choice for an ideal collaborator.

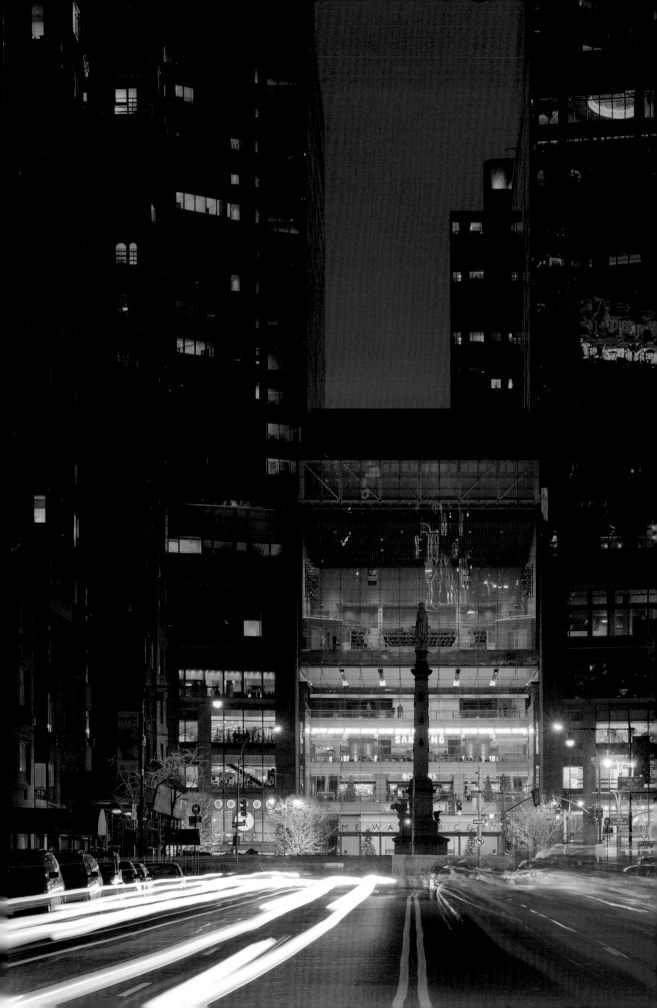

As a pure glass wall seen from the ground, Double Cable-Net Wall at the Time Warner building has the remarkable ability to represent large slices of the sky plane, the streetscape, or views of Central Park, depending on where you are standing. It presents a huge, dynamic, panoramic view of its surroundings and literally extends the view of 59th Street through the building, particularly because the cable-net walls are activated by the layered reflections of traffic in motion. If it had been a conventional structure with deep beams, mullions, and a metal structure framing each glass panel—in other words, if it had possessed all the depth and robustness of structure associated with a glass wall of that scale—that panorama would be entirely invisible; the view of the structure would dominate the viewer's perception.

So the project is about engaging a structural solution that supports the underlying conceptual premise. And that is the only way it can be successful. If the structural solution can't further the original idea, then why bother?

David Childs of Skidmore, Owings & Merrill was the lead designer of 7 World Trade Center and he brought us into the project early on. At the time there wasn't a complete idea about the tower, but SOM knew that the building had to have a solid base, because of the ConEdison transformers contained there, and that this base would somehow have to merge with the tower above. SOM were thinking at the time of a kind of Slinky, where the metal base would consist of very dense horizontal bands that would then become more open as they stretched up the building.

The broadest influence we brought to the project was to conceive of the overall building as a structure able to respond luminously to its immediate environment. Both the local urban conditions and the particular quality of light downtown became the organizing principle of the design. We saw the 7 World Trade Center as a volume of light where the glass curtain wall and podium would act as reflectors and subtle reimaging devices of its surroundings. When you look at the building, your attention is drawn to the quality of light happening at that very moment.

The tower's curtain wall dematerializes the building. We did this with an unconventional curtain wall and a unique skin for the base of the building. Instead of having the curtain wall interrupted at the floor plates, we allowed the glass unit to pass over the floor edge and terminate at the midpoint of the recessed spandrel, thereby defining the floors by revealing a void. Below the resulting floating portion of the IGU (Insulated Glazing Unit), a reveal allows light to be present behind the curtain wall via a formed spandrel section. The spandrel section consists of an inclined polished blue reflector at the sill that reflects daylight up onto a vertically curved specular metal ribbed panel, which in turn projects the light out through the backside of the floating section of the IGU and down to the viewer's eye. The result is that the tower's structure is embedded with blue light and therefore merges with the sky.

Framing the lobby and entrance, the base of the building contains two rows of transformer vaults. The design of a skin capable of venting the heat generated by the transformers while simultaneously responding to a very active urban environment was called for. Historically that section of Greenwich Street had been an uninteresting and uninviting industrial space—very few people used to walk at street level there because you were below the podium level of the World Trade Center site. Everyone on the design team recognized that the whole context would be transformed by the time the development was completed, especially because Greenwich Street was extended across the original World Trade Center site. We realized that the building would soon be surrounded by other large buildings and that we would need to find a source of light to activate the base of the building. On those narrow streets the light comes in at oblique angles from narrow slivers of sky, and so you never really get light from a perpendicular direction. This situation led us to develop variously polished and specifically oriented prisms—stainless steel prisms that can be programmed across the whole façade of the building to capture the ambient angles of light coming down the street.

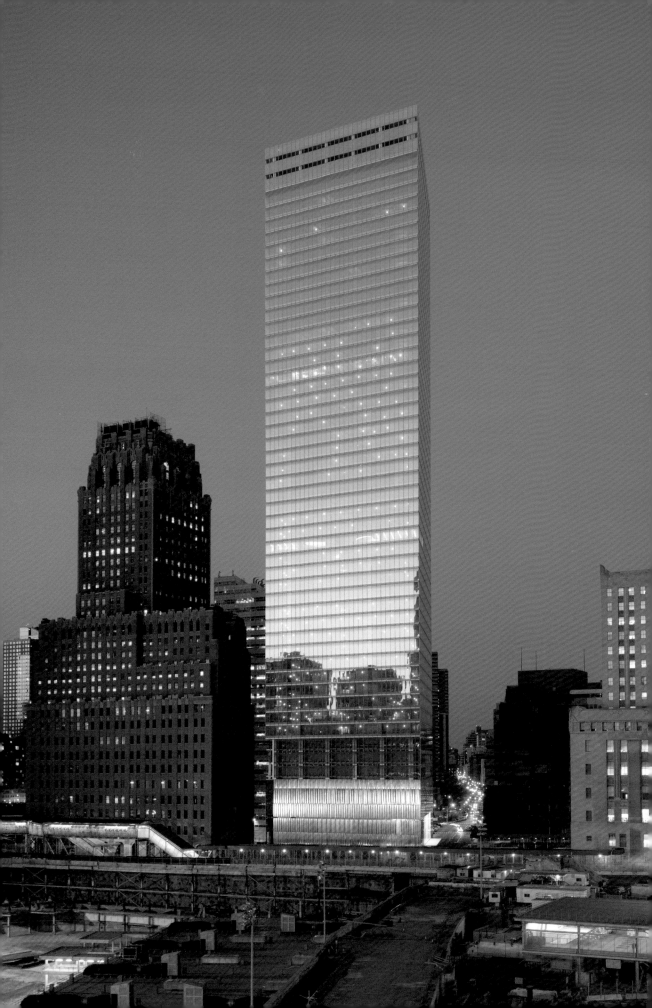

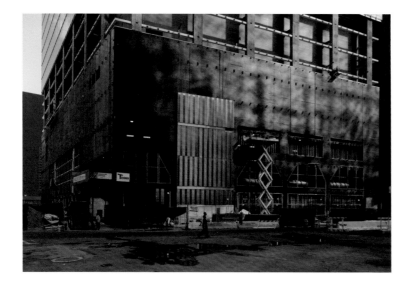

The podium screen at the base of the 7 World Trade Center was developed out its limitations: the stainless steel screens needed to be 50 percent open to allow for the natural ventilation of the transformers. We then realized that the building would have two different lives: one in the daytime and one at night. We could match the 8-inch depth of the curtain wall spandrel with an 8-inch deep podium skin, creating a sense of the building as an extruded volume of light.

We had to ventilate the transformers adequately, deflect the views of the vaults day and night, and provide an aesthetic contribution to the urban environment equal to the cultural activity surrounding it. The solution was to construct two layers of prismatic wire. The interior layer consists of small-profile stainless steel prisms with a matte surface set back within the 8-inch cavity that also contains lighting for the nighttime. Because our eyes focus on surfaces that have the brightest value, views into the transformer vaults are blocked. In the daytime,

your eye stops on the outermost skin and at night, it stops on the second layer of skin, obscuring views of the transformer vaults despite the screen being 50 percent open to the outside.

The inner prisms are oriented to maximize the broadcast of artificial light at night. The outer ones are oriented to capture the various oblique angles of daylight and ambient light. As with the curtain wall, we are embedding light into the building, utilizing the depth of the mullion, dematerializing its volume, and revealing a level of perceived depth not usually associated with architecture. Additionally, pedestrians activate the façade: we collaborated with Marek Walczak of Kinecity to develop a camera-recognition system and lighting program that illuminates the cavity of the podium with brighter bars of blue light that are triggered by people walking along the building's sidewalk.

Because we have typically worked in collaboration with architects, it was an unusual opportunity to have a client come to us and ask us to undertake the primary planning and design responsibility for what became a series of new buildings as well as the general circulation and renewal plan for the campus of the Israel Museum in Jerusalem. Given that our work has consistently focused on shaping people's experience of space on an ever increasing scale, however, it was only natural for us to take on the design of the buildings as well. The Israel Museum campus consists of a unique and wonderful collection of existing buildings, designed by Alfred Mansfeld and Dora Gad and including Frederick Kiesler's Shrine of the Book, and an extraordinary sculpture garden by Isamu Noguchi. It's a very strong collection of buildings that represents a significant national asset for the country, even without counting the remarkable collections that belong to it. James Snyder, the museum's director, read about our Dey Street Passage project with interest, since several components of the museum needed to be put below ground to solve issues of accessibility, air conditioning, and controlled daylight. The museum needed someone who would respond to the unique character of the site—and someone who would generate an architectural vocabulary that would be particularly sensitive and responsive to the existing buildings as well to the varying conditions of landscape and light across the site. It is a project requiring a strategic renewal of the museum campus, not an iconic project that would overshadow the richness of the existing campus. So the job came to us over a period of time and coalesced into a commission to do the new buildings and reorganize the circulation, with architects of record Efrat-Kowalsky Architects and A. Lerman Architects.

Israel Museum, Jerusalem, Israel, 2005–2010
Aerial view of the Israel Museum campus, highlighting the conceptual layout for the new main entry, route of passage, and gallery entrance pavilion

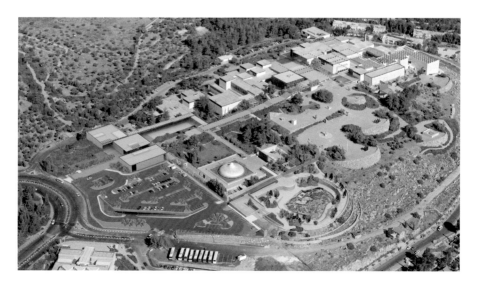

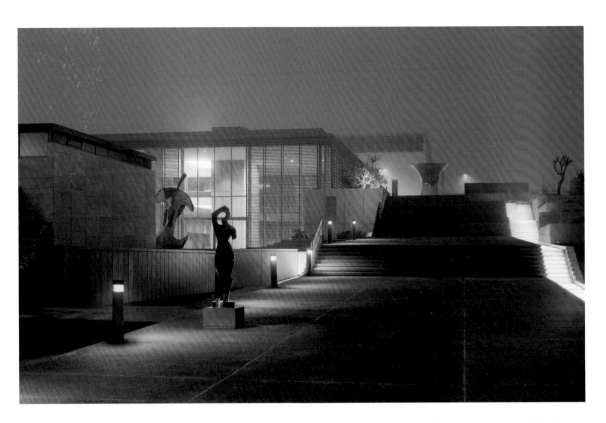

When you are in the glass buildings, you are not subjected to direct sunlight or the thermal gain associated with it. Instead, much as in the tradition of early Middle Eastern architecture, the interior surfaces are all indirectly lit, and the strong light is tempered by specifically articulated light screens. All of the glass buildings that you see above ground are completely shaded by structures that have a great empathy with the existing architecture of the museum. As you move up through the campus you transition into a passageway, referred to as the Route of Passage, which penetrates the hill below the campus under the original exterior walkway. Offering no shade and many steps to climb, the original walkway had been the only route to the museum entry. In contrast, the Route of Passage's temperature can be regulated and it is free of steps, bringing visitors directly to the heart of the museum's galleries.

Because the passage is below ground, we wanted those people choosing this route to share a comparable experience of views of the landscape and quality of light to those walking above. To achieve this effect, we introduced light to the passageway from one side, through water and cast glass, into a slot adjacent to the walkway, which is visible through translucent glass. As you walk up the passageway, you see the play of light and water projected down onto the translucent glass wall in this below-ground space. The passage widens intermittently into small planted courtyards that permit you to move out of the passageway and climb stairs up into the garden.

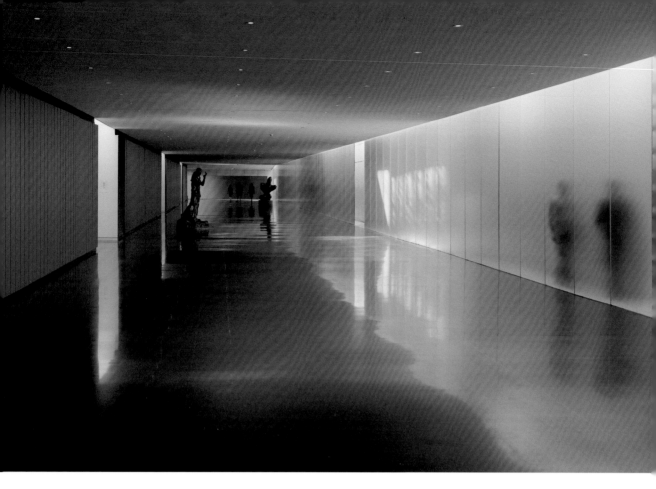

Israel Museum: **view looking south inside the
Route of Passage beneath Carter Promenade**

The Route of Passage becomes a passageway of the sublime, in that it extracts elements of landscape and light that can be observed in constant transformation as you move up through the space. It is really about orchestrating one's sequence through the architecture—arriving at the campus, going to the bookstore, buying a ticket, having lunch, and then moving up to the galleries to see a certain collection. You try and make that experience in tune with the remarkable landscape and light qualities that are so unique to that place. Our goal is that your experience of moving through these buildings will change your awareness and appreciation for the site.

The complexity of the Israel Museum project has been immensely satisfying, and we hope to continue working at this architectural scale. Many of the public spaces we have done—the Lichthof atrium space for the German Foreign Ministry, for example —are singular spaces. Each has a fixed presence within its immediate context and is therefore viewed in a very specific way. That limitation has its own challenges, but with these larger projects we are able to orchestrate an entire sequence of spaces—one's passage through the environment, buildings, and landscape—developing different ways of informing visitors of the characteristics of the environment that surrounds them. It is about relying on the creation of moments that are key to your sensation of space that enriches your experience—so it constitutes a more subtle influence.

Often in architecture you have one space linking another without any clear continuity, as if the spaces were a series of isolated, programmatic environments. I think in our work there will always be an awareness that light is being used to mediate each of these environments and their transitions, making each space transformative and engaging.

To go back to my early films, there is no question that they reveal my underlying interest in trying to understand how to have people recognize the complexity and richness of the environment that they are in. All my work is about enhancing one's perceptual awareness of the attributes that are so particular to a location and turning that perception into something that is enriching.

What we are always trying to strive for in these urban projects is to make people aware of nature—to reveal nature's presence despite our assumption that we are divorced from nature in the city. We consistently strive to conceive a way to reestablish those connections that are there but are inevitably ignored. Architecture has the potential— we would even say the *obligation*—to overcome that disregard.

Double Cable-Net Wall, 1999–2004,
Time Warner Building Jazz@Lincoln Center,
New York

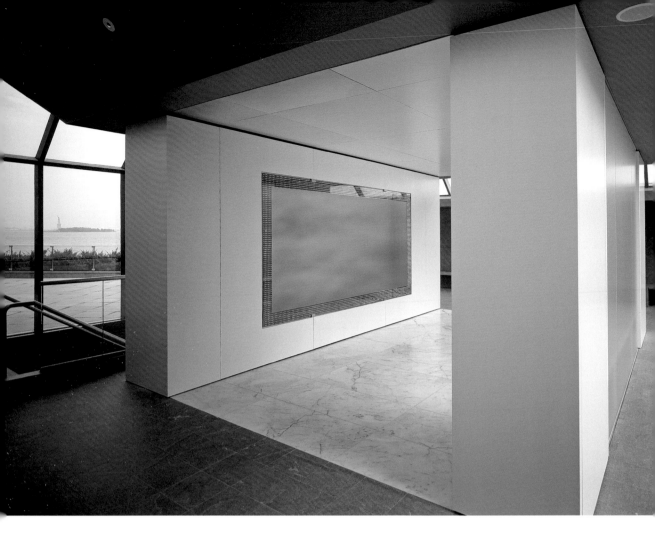

Water Light Passage, 2003–2006,
Museum of Jewish Heritage, New York,
New York

The Water Light Passage is a relatively recent project that creates a new architectural space while revisiting my early interests in film. This permanent installation is located in the Museum of Jewish Heritage in New York and makes full use of the Museum's extraordinary location overlooking New York Harbor at the tip of Manhattan—views that include Ellis Island and the Statue of Liberty.

The opportunity here was to create a meditative environment connecting the museum building housing the permanent collection and the newer building dedicated to traveling or temporary exhibitions, administration, and education. The connection between these two parts of the museum is defined by a bridge offering stunning views of the harbor. We wanted to slow down the visitors's passage across this threshold by presenting a contemplative real-time interpretation of the water and light of the harbor.

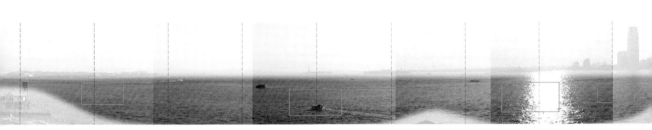

A mechanized video camera is mounted to the roof of the Museum of Jewish Heritage overlooking the harbor; it constantly searches for the brightest area of reflected light. These bright fragments of the water's surface are then processed by special software and broadcast on the large field of LEDs of the Water Light Passage. The spacing between each LED is such that the eye cannot identify the source imagery—the screen appears to be a randomly activated surface with no recognizable content. By placing a large sheet of diffused glass

with a clear perimeter over this field of LEDs, you continue to see the flickering abstract light framing a subtly resolved image of the light reacting to the caustic movement of the water's surface.

In many respects this project contains the primary elements of what I seek to explore. Amid the bombardment of information in our daily lives, JCDA's ambition is to differentiate select moments of the sublime—moments that slow us down and deeply connect us to the power of nature.

Water Light Passage, 2003–2006,
Museum of Jewish Heritage, New York,
New York

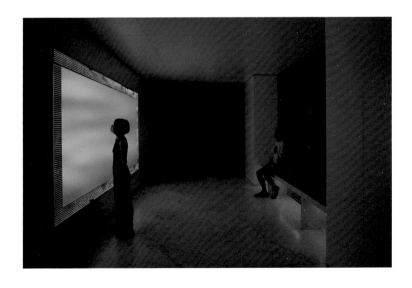

BEYOND SURFACE APPEAL

Glasarchitektur, observed Adolf Behne in writing about Bruno Taut's architecture, does not proclaim new worlds, it constructs them.[1] Behne's statement could just as easily apply to James Carpenter's *Glasarchitektur*, which follows Taut by almost a century but similarly fosters new worlds. Carpenter is not interested in proclaiming, either in terms of shouting (his work is anything but strident) or in terms of critique (his new world is not a condemnation of the world as it exists). His projects do not expend energy on exposing problems in our existing world; they gently, but with exacting precision, provide alternatives to it—extraordinary, unpredictable, and inspiring constructed alternatives. Thanks to advances in material technologies and to his extensive and fruitful collaborations, Carpenter's "new worlds" have expanded in scale and proliferated in number in recent years. With his commission for the expansion of the Israel Museum in Jerusalem, where his office is no longer collaborating with architects but has the role of design architect, one can say with some certainty that he is building architecture. As Mark Linder concludes elsewhere in this volume, Carpenter has succeeded remarkably in remaking and displacing disciplinary definitions and boundaries. In looking at Carpenter's more recent work, that remaking and displacement seems to have extended to reality itself. In describing his work, Carpenter has situated it "between memory and dream"; by suspending a series of beliefs, he consistently reveals yet more new worlds. In lightly reshuffling materiality, transparency, and the conventions of the public realm, Carpenter generates milieus of sensational, dreamlike dislocation that proffer new materialities, new transparencies, new publics, and new realities.

Carpenter's practice transcends the banal tendency to push surface to absolute flatness and glass to absolute invisibility. His projects render surface substantial, transforming perception in a way that neither reduces

it to mere naturalism nor employs the familiar estrangement techniques of the avant-garde. Going beyond surface appeal, Carpenter appeals to a new sensibility.

> It is clear that it is not by sensation that we sense the dream.[2]

> That affection which we call the dream is not of the faculty of opinion, nor of thinking, nor of sensation purely.[3]

> In a certain way, the dream is a sensation.[4]

Deftly threading together three seemingly inconsistent assertions by Aristotle about dreams and sensations, Daniel Heller-Roazen posits that rather than revealing an insurmountable contradiction, these statements "may...be read together as the components of a single theory, which admits of more than a single level of perceptual activity."[5] Sensation is at once intellectual and physical, and although seemingly precise, it is nonetheless difficult to articulate. In short, Heller-Roazen explains, dreams are perceived, sensed, but not in the same way that we typically perceive or sense. Dreams are perceptions suspended between consciousness and unconsciousness—"Beyond or before, both the presence and the absence of waking, it seems, there is something in the soul that does not cease to sense."[6] In situating his work between memory and dream, Carpenter suspends but does not discard sense. Although this suspended state is not unfamiliar, it isn't obvious how to produce or even describe it (as underscored by Aristotle's circuitous locutions). The experience of the work is "otherworldly," but not frightening; Carpenter's projects are alluring, drawing the spectator in to a new mode of perception. If the modern avant-garde relied on Brechtian techniques of estrangement for awakening the subject to an aesthetic experience—shocking the subject out of the everyday to focus attention on new possibilities—Carpenter's *Glassarchitektur* instead eases his subjects into a dreamlike state of suspension. Carpenter himself eased only slowly into this mode of production. Although one can read consistencies across his meticulous and orchestrated production of an audience, his techniques for producing what might be called a *suspended public*—a collection of individuals who share the experience of being suspended between memory and dream (even if

their new perceptions remain individualized), suspended from everyday life, from expected definitions of what it means to be a public, if only while they experience the project—have varied across his career despite consistent themes such as perception, behavior, and the relationship between nature and culture.

Carpenter's early projects drew the spectator in, but with less ease. He rendered the seemingly easier medium of film—more control and more limits than glass—more difficult by deploying avant-gardist techniques of estrangement. As Carpenter moved toward what has become his signature medium of large-scale glass interventions, the demands the projects place upon their audience have gradually lessened; at the same time, his audience has expanded: the work is less singular in ambition and therefore more multifarious in its reception. As he ventures deeper into architecture itself, it will be exciting to see that public expand yet further beyond being an *audience*—film's "public"—to becoming a collection of *suspended publics*, a collection of individuals suspended momentarily in multiple collectives that continuously reform themselves into multiple public spheres. As political theorist Nancy Fraser has argued, the way to comprehend the contemporary public sphere is not as a singular entity of consensus (as theorized by Jürgen Habermas, who coined the term "public sphere" in 1962) but as a collection of overlapping publics, some strong, some weak, but all consisting of individuals brought together by common concerns.[7] Film seems to offer a clear means of situating the subject, that is, it is an excellent medium by which the parameters of a subject's public sphere can be defined for him or her: by reducing experience to the visual apprehension of the two-dimensional screen, one can more easily produce and delineate that suspended state, thereby better ensuring the desired impact upon a particular subject. As Carpenter commented,

> In the cinema there is an implicitly designated point of view—facing
> frontally to the screen, preferably in absolute darkness so that what appears
> on the screen comprises the totality of what is visible. We are placed in a
> fixed position toward the imagery that deploys itself over time and in a
> depicted space that is non-contiguous with our own—we enter the space
> and time of film only with our minds.[8]

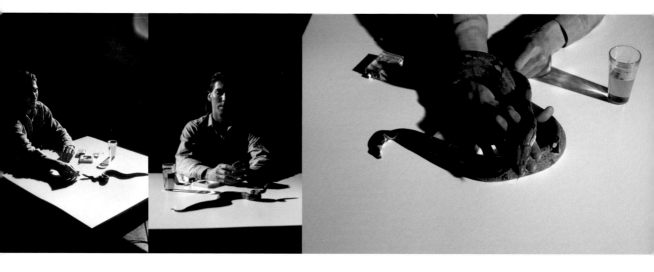

Carpenter continues by contrasting this filmic space with a more engaged
sculptural one:

> In a sculptural situation, we are oriented within an aesthetically dense
> space in which objects and configurations are fixed and we are free to move.
> It is essentially an unframed, decentered experience with no one correct
> perspective of focus, no designated viewpoint.[9]

Carpenter's film installations, which focus on natural ecological systems,
all construct this kind of "sculptural" decentered experience by filmic
means, so they fall into a zone between the precision of the film and the
indirectness of sculpture. While some of the earlier films contain the sug-
gestion of symbolic narrative—albeit deliberately frustrated narratives—
for their effect, later ones abstract the natural environment and focus
more on the relationships between perception, behavior, and the natural
world. In Confines and Cause, both filmed in 1975 and then installed in the
John Gibson Gallery in New York in 1978, animal behavior is manipulated
but not entirely controlled by Carpenter as the protagonist in a brief, con-
trolled, and suggestively symbolic tale that is never fulfilled as a complete
narrative. Both installations perfectly match the projection onto a three-
foot-square, stark white surface with a film of a three-foot-square, stark
white surface, which creates an image of a peculiarly flattened tabletop
with exaggerated shadows—a two-dimensional film where there had once
been three-dimensional experience. As Carpenter notes, "the actual table
that was filmed becomes the projection screen—the surface upon which
the film was shot, becomes the 'object' that is re-animated by the filmic
record." The surface becomes an object and then a surface anew when it
is projected, thereby complicating the very notion of surface. In Confines,
a snake slowly slithers toward the flattened, isolated forearms, seeking
human warmth. The only other objects on the table—a pack of cigarettes,

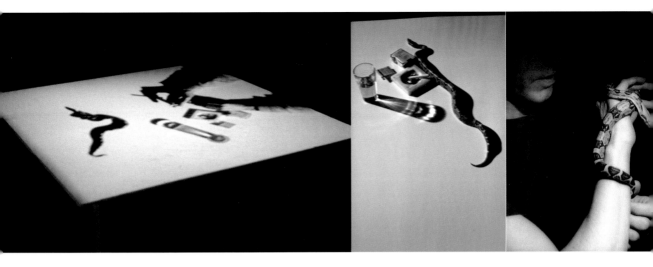

an ashtray, matches, and a drink—suggest a detective narrative. The slowly slithering snake crossing this minimalist stage only heightens the state of suspense. Even if the film—as Carpenter's wall text explains—demonstrates how "the snake as a cold blooded creature is attracted to warmer objects in its immediate environment" (the suggestion of the text is that the film demonstrates a simple scientific proof), the staging of this "proof" implies a larger narrative laced with danger, forces of attraction, and untold stories—even morality tales (the cigarettes and the alcohol standing in for Eve's apple).

In the same vein, *Cause*—also both filmed and projected onto a white square—depicts a linear sequence, thereby implying, though never specifying, a narrative. This narrative tease or frustration draws attention to the medium of film, shifting it from a medium that is generally steeped in narrative linearity to a medium of non-narrative linearity that therefore redefines linearity itself in the same way that *surface* in these films is pushed not toward minimalism but toward objecthood. *Cause* opens with only a small loaf of bread and a knife on a plate occupying the white surface. The same disembodied forearms that played such a central role in *Confines* reappear this time to cut a slice of bread and then disappear from the screen only to be replaced by a crow who first tentatively (hesitating, like the snake) and then decisively snatches the slice, eats it, and flies off screen. The sequence implies a cause-and-effect narrative, and the stripped-down setting with the black crow protagonist implies a moral, like Aesop's or La Fontaine's fables. At the same time, each of these films offers simple proof of basic needs: *Confines* demonstrates the draw of heat, and *Cause* the draw of food. The readings of these two films oscillate between symbolic and scientific registers, leaving their audience slightly unmoored but not entirely at sea; for even if a single meaning is denied, enough meaning is left intact through the sequence of actions for the audience to "read" into the films.

Carpenter's subsequent work can be seen as an effort to push the boundaries of "reading" without breaking them altogether. Every project offers multiple readings—constructs "new worlds," to come back to Behne—without pulling the rug entirely out from under the audience so as to deny the possibility of reading, or of audience, altogether.

Most of Carpenter's subsequent film projects eschewed sequential narrative in favor of more singular and more enveloping effects. Unlike most of Carpenter's films, three of these subsequent films do not include or involve animals, although they still do engage the theme of human perception of the natural world. *Orientation, Vortex,* and *Shaking* all create environments where mechanical manipulations of natural forces dislocate reality without abandoning it altogether. *Orientation,* from 1978, combines projection and objects to create an installation that makes magnetic force visible: four film loops depicting the four compass points are projected on the gallery walls while two copper-wrapped steel cylinders, measuring 14 inches in diameter by 8 feet, are suspended in the center of the space. Alternating electric currents cause the cylinders to swing about, and the films document the swings as shifting points on the compass dial.

The configuration pushes the audience to the edges of the gallery. A pervasive, invisible natural force—magnetic force—that affects all of us, though only imperceptibly, is thereby made visible and obstructive. *Vortex,* from 1978, documents in absolute plan view a whirlpool that appears only intermittently in the river in Lewiston, New York's Art Park. The installation shows the film of the whirlpool cut into nine separate films and projected as an abstract crosshair straight down onto the floor, with the crosshair's

Cause, 1975–1976; Super-8 film loop; view of projection in gallery installation; detail of film still; photograph taken during filming; *facing page*: detail of film still

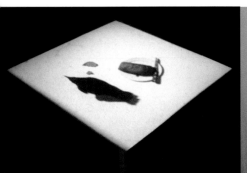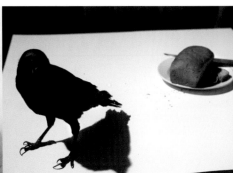

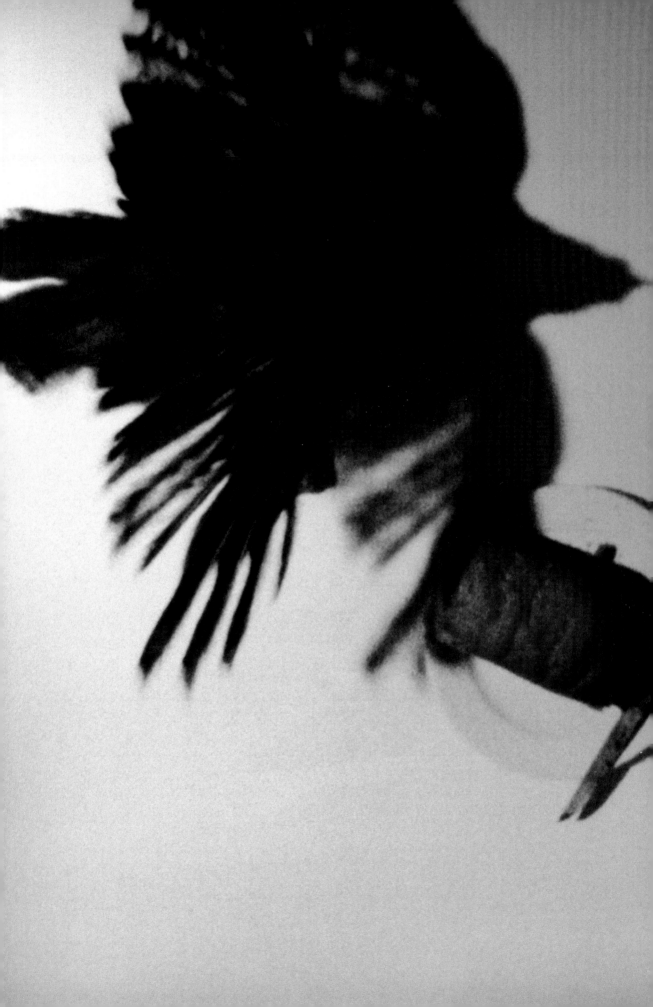

ORIENTATION: Four Super 8 cassette film loops of the compass points projected on opposing walls, two electro-magnets six feet in length whirling in the center of the room at rapid, alternate moments of attraction and repulsion, audiotrack. 1978

Orientation, 1978; Super-8 film loop installation; *above*: poster describing the project; *left*: developing the project in the studio

Orientation, 1978; Super-8 film loop installation; installation views

 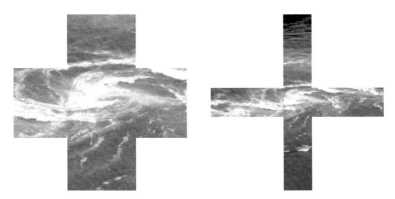

Whirlpool, 1979; Super-8 film loops;
above, left to right: still of the site; mockups
of the film projections

center seemingly drilling right into the floorboards. If *Orientation* rendered an invisible force visible, *Vortex* takes a visible but uncontrollable force and frames it in such a way so as not to tame it, but to turn it at once into an isolated specimen (like a glass slide from an enormous microscope) and an artwork (an abstract floor piece whose fluid imagery contests its fixed frame).

Finally, in *Shaking*, from 1978, oak branches are mechanically vibrated to suggest but also exaggerate the wind's movement of branches in the forest. Because each branch is separate, they appear as distorted trees, each transforming into an underscaled trunk for overscaled leaves. In the installation, six of these vibrating branch films are projected simultaneously in one dark room, creating a beautiful if slightly menacing dreamscape of wildly rustling foliage.

Shaking, 1978; Super-8 film loop;
right: view of the installation;
facing page: poster describing the project

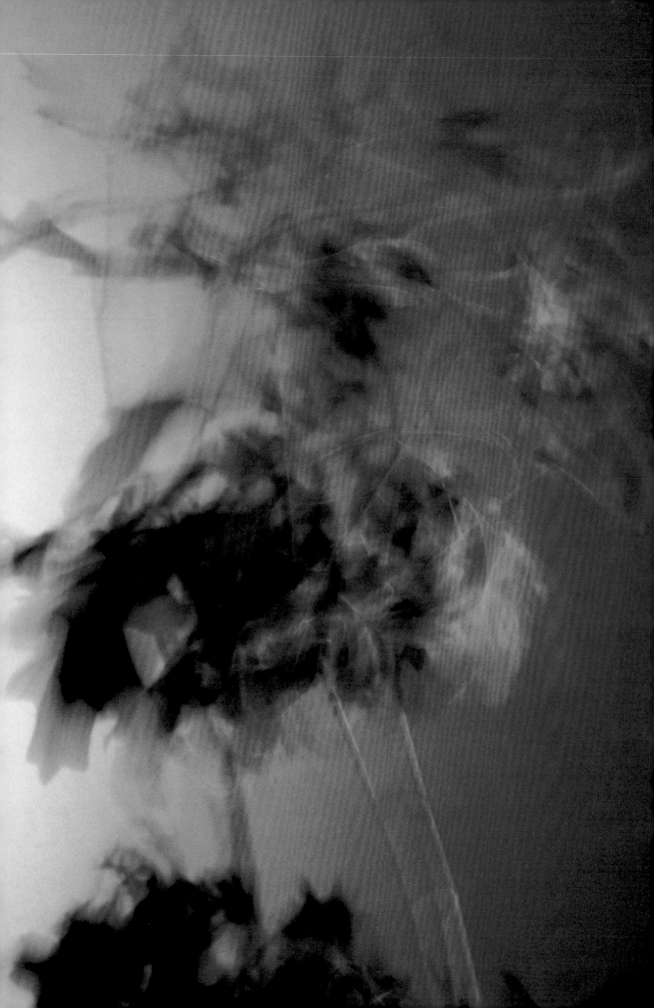

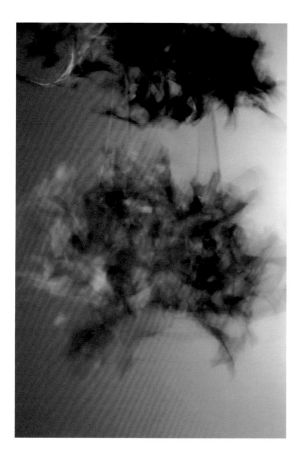 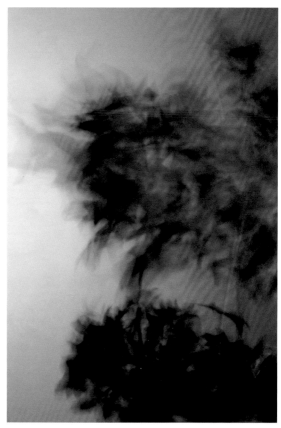

Shaking, 1978; Super-8 film loop; film stills

All three of these films document while simultaneously manipulating natural forces; by suspending beliefs and revealing unknowns, while not completely controlling them, these films occupy that zone between memory and dreaming, between the rational or informational and the irrational or imagistic. To achieve these dreamlike effects, they all rely on some kind of device, mainly mechanistic. In *Orientation*, it is the materiality of the bars and the electric current; in *Shaking*, it is the motorized movement of the branches. These films shift Carpenter's technique from one of staging, performance, and narrative to one of technique, environment, and abstraction. The installation constructs a space that is not representative of nature but that does represent our perception of nature by restaging it. The viewing of this performance choreographs a new phenomenological experience that engages but doesn't mimic the "real" natural world, thereby always reminding us that that very reality is in itself a construction.

This filmic reliance on or introduction of a mechanical device is not an uncommon means of bridging the worlds of reality and dreams. In Michel Gondry's surreal and enchanting film of 2006, *The Science of Sleep*, the protagonist Stéphane hands his neighbor and love interest, Stéphanie, a pair of clunky 3-D glasses that he's constructed, urging her that she "can

see real life in 3-D!" Stéphanie grumbles that the world already exists in 3-D, but in putting on the glasses, she recognizes Stéphane's magic: although real life is indeed in 3-D, one rarely ever really *sees* it.

If Carpenter's devices weren't so present, that balance would shift to the supernatural, magical, or mystical. By maintaining the balance, the subject remains actively engaged. At the same time, the strategy here differs greatly from the estrangement techniques of the early twentieth-century avant-garde that were picked up again by the late twentieth-century deconstructivist and poststructuralist avant-gardes, where the audience was distanced from the narrative to always be rendered conscious of the construction of the narrative and to be able to read a lesson in that construction, whether a lesson of class difference or of a lack of foundational origins and conclusive certainties. In Carpenter's projects, as well as in Gondry's *Science of Sleep*, such lessons are not at play. Instead, the focus is on the possibilities that lie in that difficult-to-articulate realm between constructed control and unanticipated effect. Reality, for Carpenter, isn't altered in such a distancing way as to critique it or call it into question in the manner of a project of estrangement, structuralism, or deconstruction (the dominant forms of twentieth-century critique), but instead to expand reality to a state of *suprareality*.

The constructions that mediate Gondry's reality and dreams locate this expanded state in childhood, a time when reality itself can often be so startling that the line between it and the imagination is rendered productively fuzzy. Carpenter, on the other hand, generates this expanded state not by evoking childhood but by turning to the accumulated and intertwining effects of technique, materiality, environment, and sensation. The *Retracting Screen* project in Dallas, Texas (1993), for example, mixes equal parts Mies and Houdini to push beyond reality. A simple 10 foot, 1.75 inch × 7 foot retractable plane is more than it appears to be. Constructed of a pair of 12-millimeter annealed glass planes, each consisting of eight separate panels, themselves paired around a urethane-based interlayer, the screen, which separates a dining area from a private gallery, simultaneously reflects and absorbs all that surrounds it, transforming dinners (and diners) into artwork and integrating artwork into a meal. The panel facing the gallery is made of 1-inch clear glass with beam-splitter coating, which

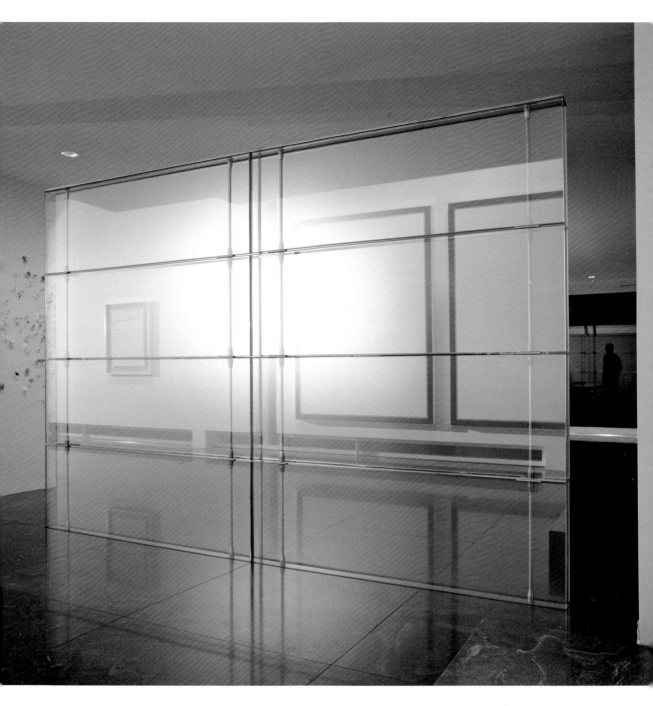

Retracting Screen, Dallas, Texas, 1993
View at night of glass screen

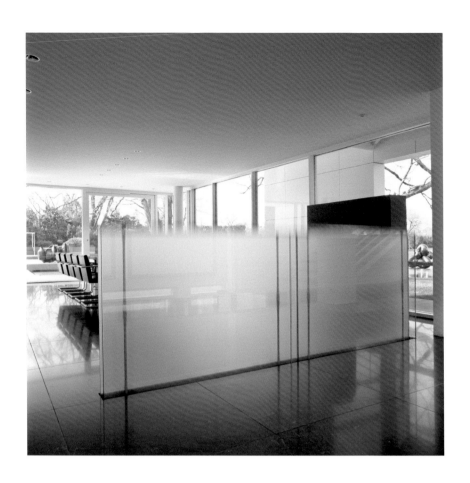

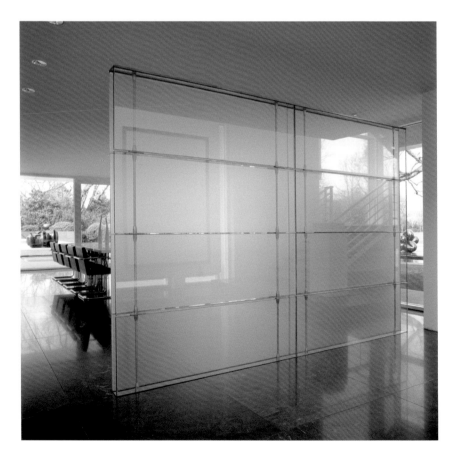

is laminated to half-inch clear glass (with the coating on the inside). In contrast, the side facing the dining room consists of half-inch acid etched glass, laminated to a second layer of the same, with the acid etching on the outside faces. The entire wall appears to be a simple wall of glass, but the result of this subtle layering, laminating, and facing yields complex effects of absorption and reflection. Additionally the structure, which rises out of the floor like the glass wall of Mies's Tugendhat House in Brno, seems to be held up by magic: frameless, it is cantilevered off a steel beam in the basement and held in tension by four steel rods that are anchored to that beam and to a header plate at the top. Consequently, the 7,000-pound screen simply floats. Reality isn't denied; it's enhanced by manipulating the material to create simultaneous optical effects of reflectivity, absorption, and weightlessness.

In this state of suspension—between reality and dreams—the world isn't turned upside down, but it is slowed down, freeze-framed into another mode. Caught in this mode, the viewer pays attention not to critique what exists already but instead to glimpse what may happen. Carpenter's projects are *sensational* in that they are fabulous, wondrous, and marvelous, but also in that they heighten the senses—they induce a bodily response. As Carpenter notes, "there is a tactility to the ephemeral."[10] Given projects awash in light and color, such as the *Structural Glass Prisms* (1985–1987) for the Christian Theological Seminary's chapel in Indianapolis, by architect Edward Larrabee Barnes, it is easy for Carpenter's statement to be misconstrued as placing his ambitions solely within a phenomenological register. The *Glass Prisms* create extraordinary luminous effects within Barnes's pure space: the prisms abstract nature by turning light into colorful patterns on the wall, and they also reflect nature by projecting the effects of passing clouds and birds, as well as the wind moving through adjacent tree branches.

Like Carpenter's films, this mixture of abstracting and reflecting nature constructs a space that is as evocative as it is contemplative. In part because of the *Glass Prism*'s particular mix of color, reflection, and abstraction, and in part because of their context, there is a natural affinity with projects like Steven Holl's Chapel of St. Ignatius in Seattle or Peter Zumthor's Bruder Klaus Field Chapel of 2007. All of these religious proj-

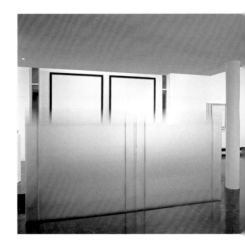

Retracting Screen, **Dallas, Texas, 1993**
above: view from the dining room of glass screen retracting into the floor; *facing page, top*: view from the gallery of glass screen retracting into the floor; *facing page, bottom*: when deployed, the screen separates the dining room and gallery.

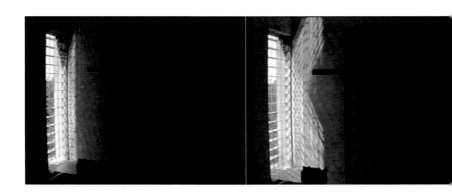

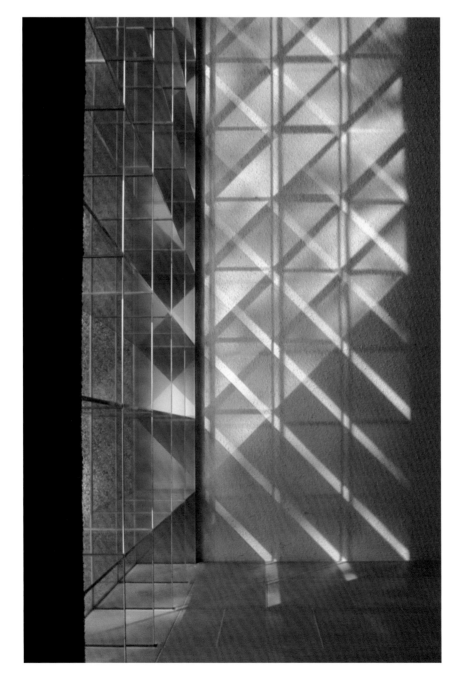

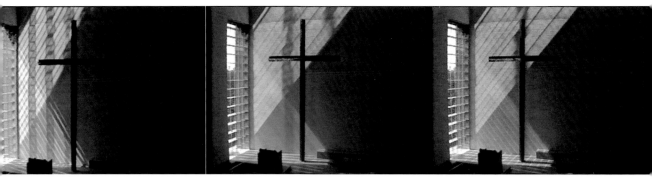

ects are contemplative and elemental, and their quiet simplicity is animated by plays of light. But while Holl and Zumthor would be the first to admit that part of their agenda is to provide an antidote to the chaos of metropolitan existence by creating an other world of phenomenological effects—a world of elemental effects and bodily sensations—Carpenter's projects, while they flirt with this agenda, never turn their back on reality itself. He succeeds in walking that line between endorsing reality in a way that descends into mere mimicry or natural worship, and critiquing reality using the methods of the twentieth century avant-garde. This line is where Carpenter's originality lies. Steven Holl claims, in his article "Phenomena and Idea": "To open architecture to questions of perception, we must suspend disbelief, disengage the rational half of the mind, and simply play and explore. Reason and skepticism must yield to a horizon of discovery."[11] Carpenter's work, on the other hand, hardly disengages the rational half of the mind; instead his projects keep the rational in constant dialogue with the irrational, the imaginary. When viewing the hovering glass of the *Lens Ceiling* at Richard Meier's Federal Building and Courthouse in Phoenix (1997–2000), for example, the reality of the weight of the glass lens competes with the airiness of its hovering luminosity.

One reading doesn't cancel out the other; the two simultaneous interpretations engage each other to create an unworldly and yet suspenseful effect. Similarly, the *Periscope Window* in a Minneapolis residence designed by architect Vincent James directly involves the body with its surroundings in a phenomenological sense, but it also foregrounds rationality. As with Carpenter's films, the device or technique of the *Periscope Window* never entirely absents itself from the effects that it generates.

Eighty glass lenses and fourteen angled mirrors create the wonderfully bizarre effect of a horizontal, multiplied, and slightly distorted window showing the sky, overhead trees, and changing effects of light. The

Structural Glass Prisms, **Christian Theological Seminary, Indianapolis, Indiana, 1985–1987;** *above*: **film stills over the course of the day;** *facing page*: **the depth of the window is extended to match the depth of the building's walls.**

Structural Glass Prisms, **Christian Theological**
Seminary, Indianapolis, Indiana, 1985–1987;
above left: diagram of the 32-foot monolithic
glass lengths and short horizontal lengths;
above right: the view is uninterrupted by
the vertical glass columns and horizontal
glass sections; *facing page*: view of the play
of projected and reflected light

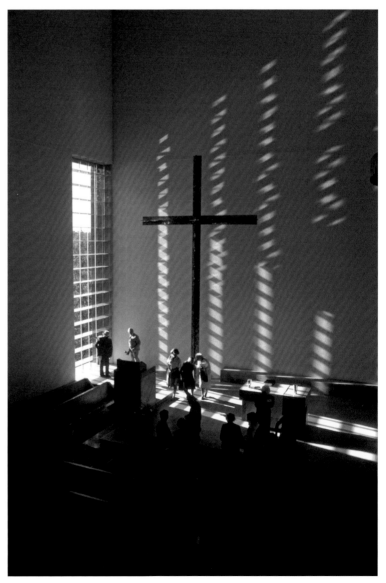

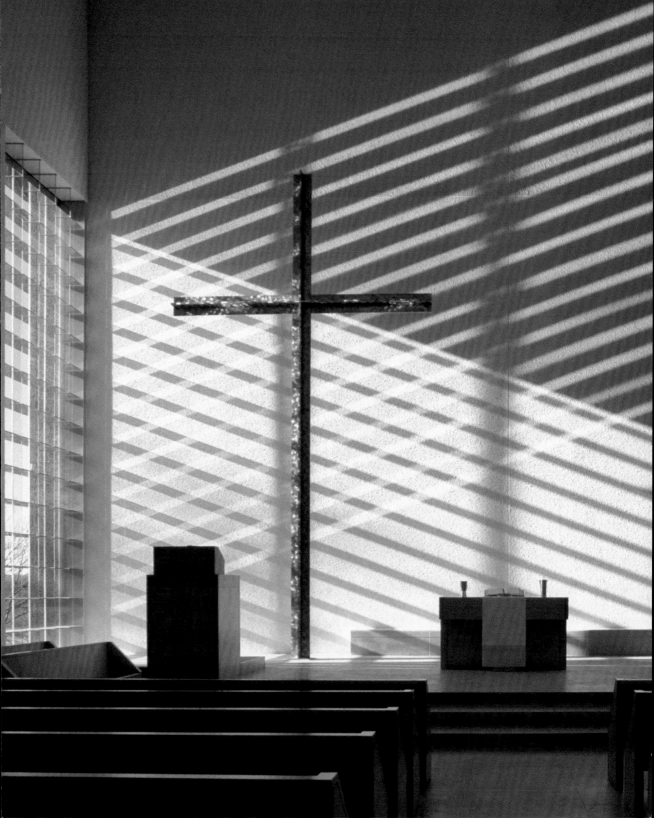

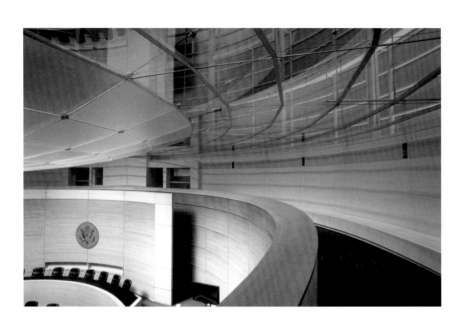

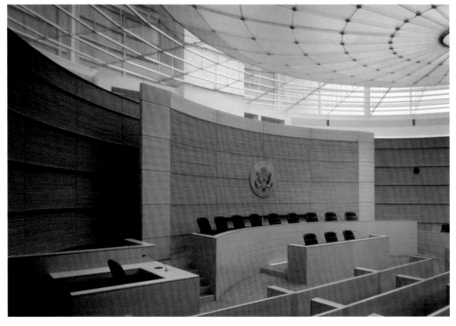

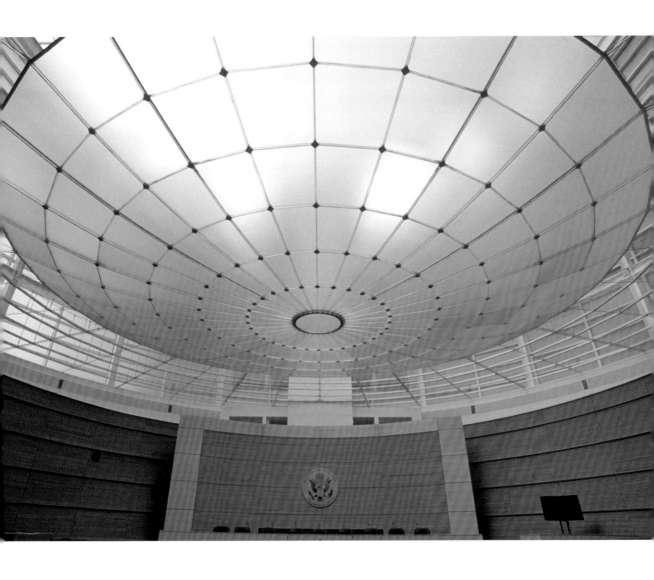

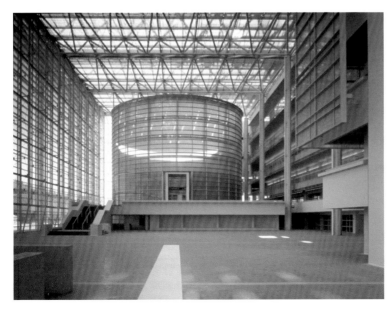

Lens Ceiling, Phoenix, Arizona, 1996–2000
facing page, top: The clear perimeter glass
frames the diffuse rolled-glass lens; *facing
page, bottom*: view of the courtroom and
viewing gallery above; *above*: the clear
perimeter glass allows views into the
courtroom; *left*: the Special Proceedings
Courtroom located in the public atrium

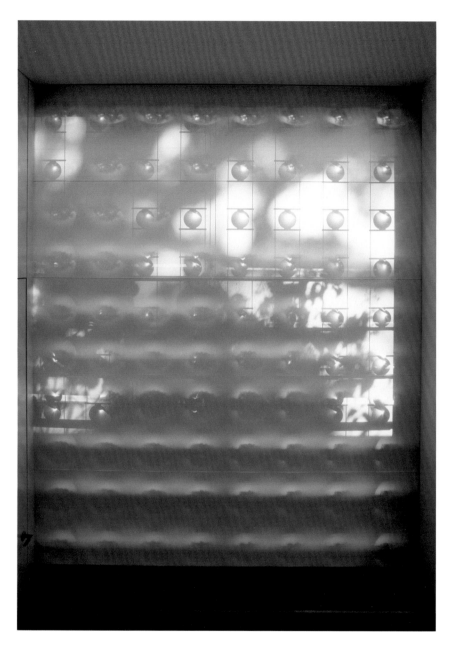

Periscope Window, **Minneapolis, Minnesota,**
1995–1997; *above left*: **Periscope Window on a**
cloudy day; *above*: **view of the Periscope**
Window at its most active

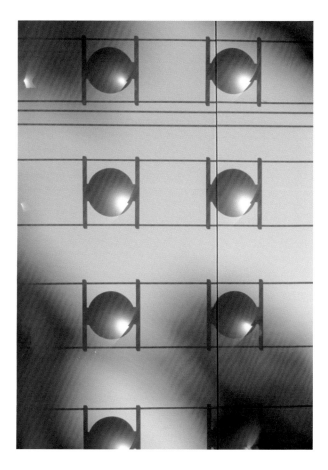

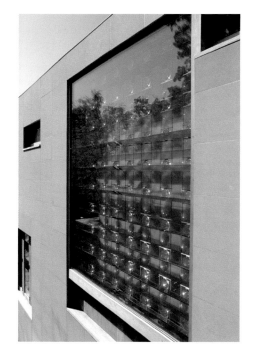

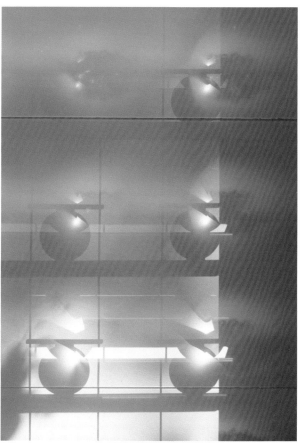

Periscope Window, Minneapolis, Minnesota,
1995–1997; *above*: behind the exterior
insulated glass are the tension rods,
horizontal mirrors, and cast-glass lenses;
above left: detail of the lenses seen through
the acid-etched glass; *left*: detail of the lenses'
projection onto the acid-etched glass;

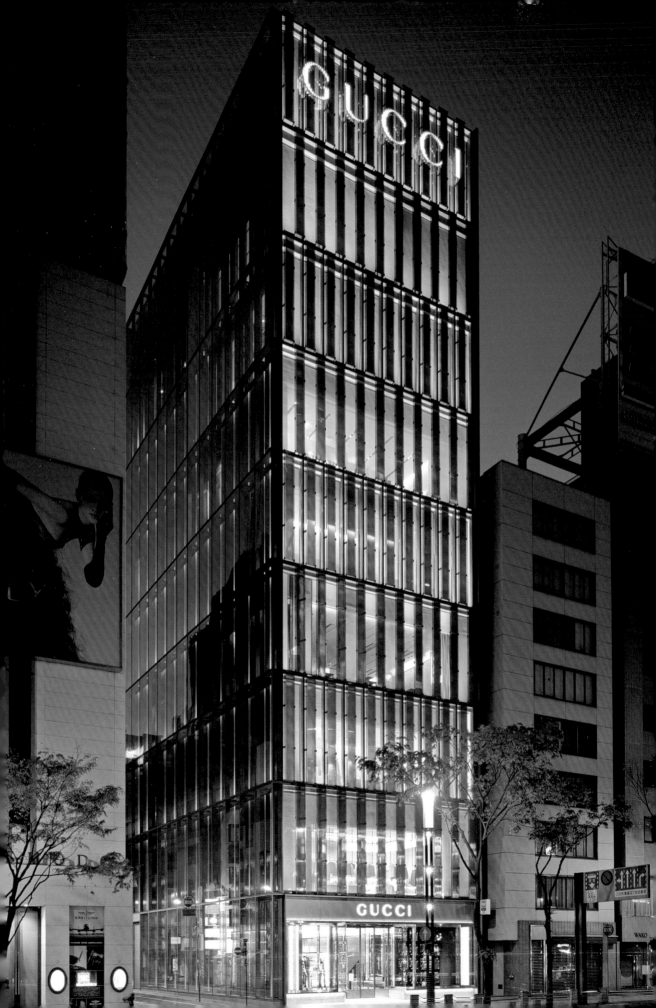

project reframes information; here, a window is no longer about framing a single, tamed view of nature but instead draws the viewer's attention to the very phenomenon of our perception of the environment at large. "Light embodies information; it does not just illuminate surfaces," Carpenter argues. Part of that embodied information is understood experientially, not to reinforce an intuitive ontological essence but rather to augment the intellectual information of material and technique that parallels this embodied information.

If light is understood as embodying information rather than merely illuminating surfaces, it becomes a thickened thinness as opposed to a minimalist thinness: Carpenter toys with the modernist mandate of transparency, thickening its effects.

> Lots of people are trying to create the lightest and most transparent glass walls. What happens, though, is that the glass disappears, and the structure itself becomes the dominant visual element. We are working from a different direction. We want the glass to have a material presence. The structure is reduced to ensure that the quality of light is the dominant factor.[12]

Thinness here, in other words, does not mean surface, superficiality, or minimalism, but a deepening of the transparency to create depth out of surface. The Gucci Ginza store in Toyko, Japan, whose exterior was designed by JCDA (2003–2006), has a double skin of custom, roller-pattern, transparent bronze prismatic glass weaving in and out of a crystalline skin of water-clear glass, which creates rippling golden patterns across the entire façade that refract and reflect the sun.

This "Gucci Glass," designed especially by Carpenter for this project, creates visual depth out of actual thinness. At night, the glass tower looks like a dematerialized Seagram Building: the inner façade glows with a bronze light and the reflective cast glass outer screen wall elements become opaque, resembling the suspended I-beams of Mies's tower. In the *Lichthof,* the primary public space of the German Foreign Ministry in Berlin (1997–1999), designed in collaboration with the architects Muller Reimann and with Schlaich, Bergermann und Partner as well as Mathias Schuler of Transsolar, modernist idioms are similarly transformed, but this time it is transparency itself that is given depth.

Gucci Ginza, Tokyo, Japan, 2004–2006
At night the layered glass curtain wall transforms the structure into a shimmering jewel box

At the *Lichthof,* Carpenter created a public space with a glazed roof and façade. While the project appears to be a simple and minimal glass curtain box, it is in reality made up of many elements working in concert to increase the light within this north-facing courtyard while modulating heat gain. Specular aluminum reflectors mounted in the roof draw light into the furthest corners of the courtyard. Three glass coatings in the façade affect heat, light, and color, resulting in a semitransparent mirror façade that creates a visual play of reflections and transparent views. Institutional transparency is here rendered in all of its actual complexity. Additionally, horizontal bands of glass cantilevered from the façade and coated with dichroic film transmits and reflects light to create a constantly changing field of color on both sides of the façade. In an elegant thick-thin play, context is flattened onto the façade as a dense two-dimensional screen of reflectivity and transparency, while air is transformed into a volume of color.

The *Moiré Stair Tower* (1999–2002), designed for Murphy Jahn's Deutsche Post Headquarters in Bonn, Germany, uses pattern to collapse the distinction between reflectivity and transparency still further. The prismatic stair tower that connects the building's three floors, provides a viewing platform, and acts as a luminous built beacon at night is glazed with a grid of 15 centimeter × 6 centimeter rectangles that are mirrored on the outside and bright blue on the inside. From the outside, the field of floating rectangles directly reflect the Rhine river scenery surrounding the building and play with the more diffuse reflections of the transparent glass that surrounds them. Inside the tower, the suspended blue rectangles become idealized abstractions of sky, set against views of the real sky outside. Because of the geometry of the prismatic stair tower, in certain views the intense blue rectangles overlap with one another or with the mirrored squares, generating multiple moiré effects of rippling motion. At night, the entire prism emits a bluish glow, again creating a volume of colored light. Light is a material, Carpenter argues, "It has weight. It has body. And it can be bent."[13]

Even the etched and laminated treads and landings of the *Moiré Stair Tower* are made from glass, further creating a dislocated space suspended between dreams and memories. Dematerializing horizontal walking sur-

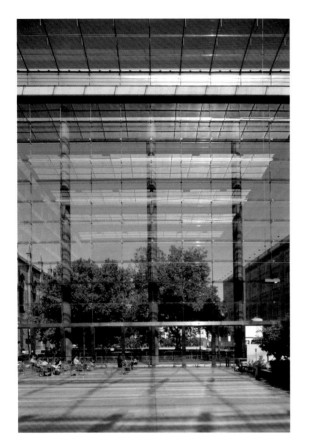

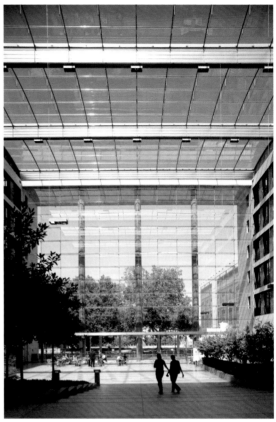

Lichthof, German Foreign Ministry, Berlin, 1997–1999; *left*: the façade's slight reflectivity is framed by a less reflective border of glass; *right*: view of daylighting reflectors lining the roof-support beams

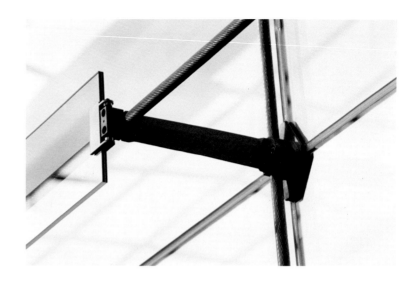

Lichthof, German Foreign Ministry, Berlin, 1997–1999; *left*: view at dusk showing the effects of the façade's semi-transparent glass; *above*: the cast stainless-steel struts are cantilevered to support both the horizontal cables and dichroic glass bands; *facing page*: the curtain wall layers reflected and transmitted views.

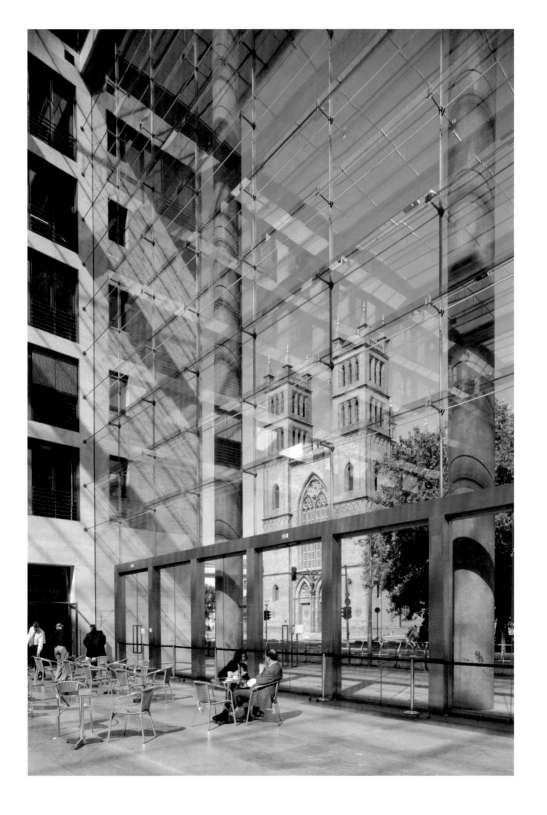

 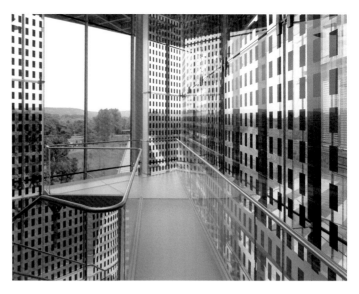

Moiré Stair Tower, **Bonn, Germany, 1999–2002**; *facing page*: nearly every detail of the Moire Stair Tower is glass; *above left*: view of the second-story viewing platform; *above right*: the third-floor platform looks out onto the Rhine River and surrounding parkland

faces while also pushing the structural possibilities of glass has long been a theme of Carpenter's work. As early as 1987 he designed a *Luminous Glass Bridge* for a private client in Marin County, California. Although never built, this project provides a transition between Carpenter's film projects and his subsequent glass installations. *Migration*, shot in 1978, consists of six separate films of a shallow river in Puget Sound where salmon migrate. The installation is projected onto a gallery floor to create a sequence of images that parallels but does not recreate the stream. Visitors circulate around the projection as if they are walking alongside the river itself. Each film frame is repeated three times, slowing the flow of the water and the salmon while simultaneously increasing the reflectivity of the water's surface. In the *Luminous Glass Bridge* project, Carpenter returns to this parallel, constructed river by designing a bridge that is like a suspended river made from post-tensioned glass planks. Three reflective panels occupy the bridge's surface like three flattened and transparent walkers, reflecting the surrounding landscape and gently pivoting out of the way to permit a pedestrian to move by.

Sixteen years later, Carpenter succeeded in constructing a floating river/glass bridge, once again by Puget Sound. The *Luminous Blue Glass Bridge*, which floats above the lobby of the Seattle City Hall designed by Bohlin, Cywinsky, and Jackson Architects (2001–2003), which, at 70 feet, is just about the same length as the projected *Migration*, connects the new city council chambers to the city administrative office building and mayor's office, offering a stunning view of the Sound. Constructed of an intense blue translucent glass, the bridge seems to be an elevated stretch of water: a place where everyone can walk on water in midair.

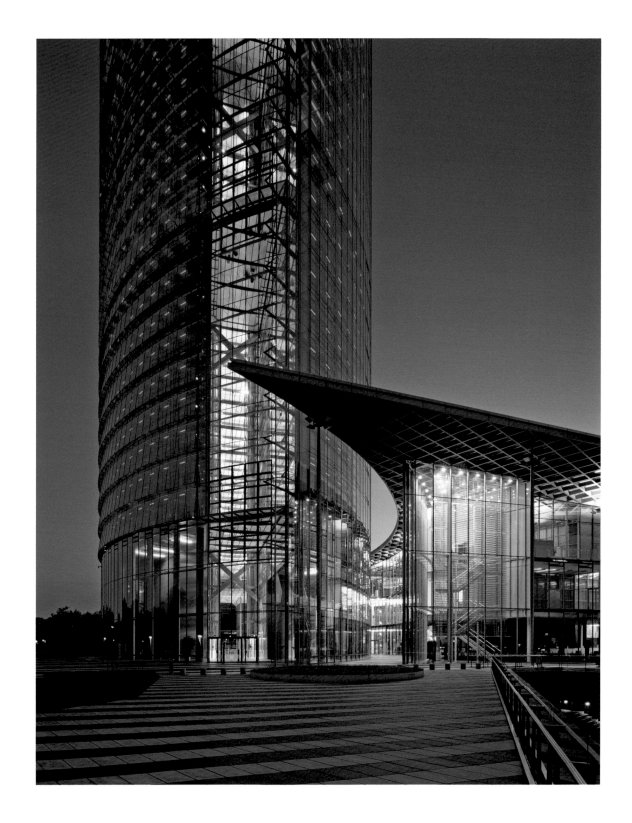

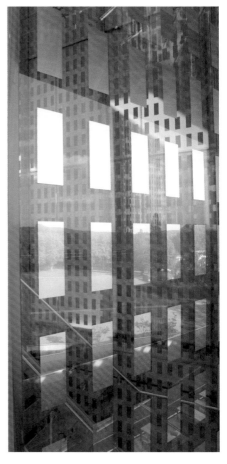

Moiré Stair Tower, **Bonn, Germany**, 1999–
2002; *facing page*: the stair tower provides the
vertical circulation for the base building;
above left: view looking up through the glass
stairs and floors to the skylight; *left*: view
looking down from the top of the staircase;
above: detail of the landscape reflected in the
mirror side of the pattern

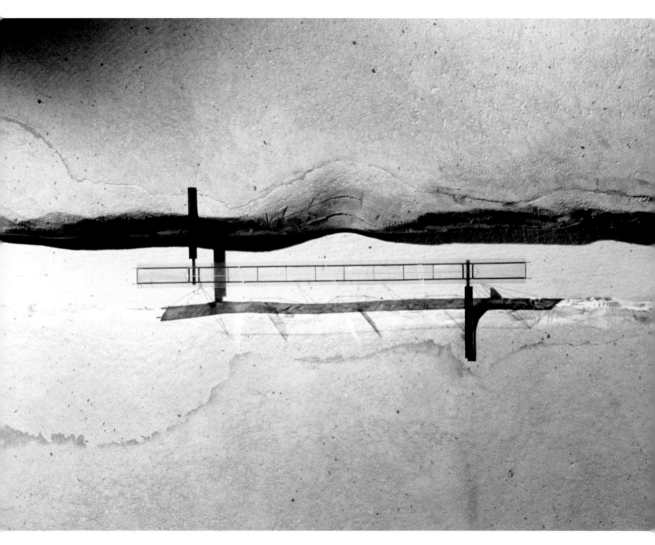

Luminous Glass Bridge, proposal, 1987;
above: the glass deck captures light and
imagery reflected off the surface of the river;
facing page, top to bottom: the bridge span is
extended along the river while the cantile-
vered supports connect each bank to the
platform; pivoting glass screens reflect the
landscape; the glass bridge exploits the
structural properties of glass under tension

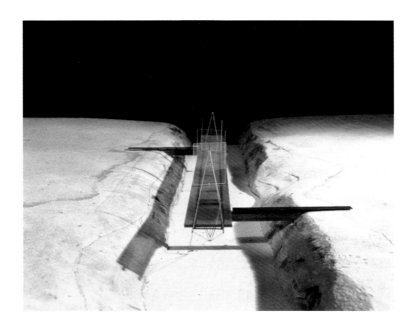

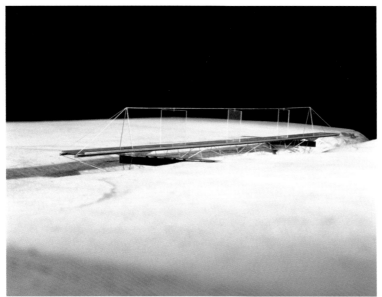

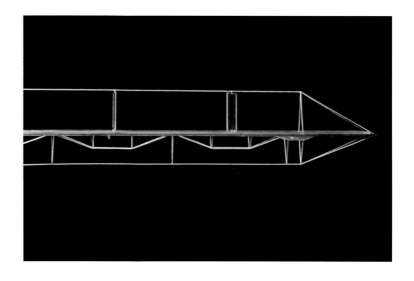

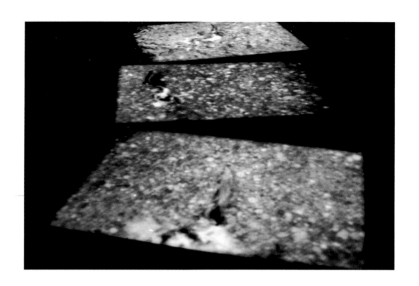

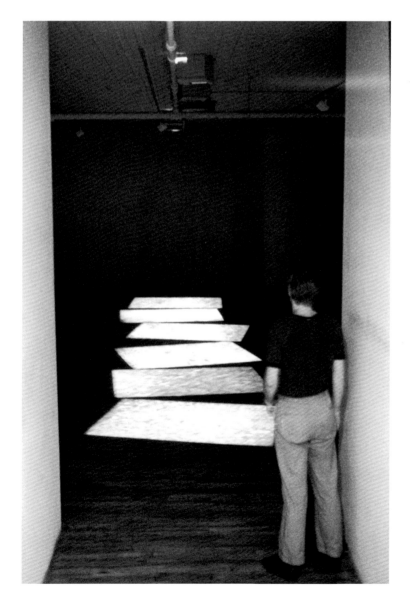

Migration, 1978; Six synchronized Super-8 film loops; *left*: installation view; *above and facing page*: installation views, synchronized so that the fish swim from one projection to the next

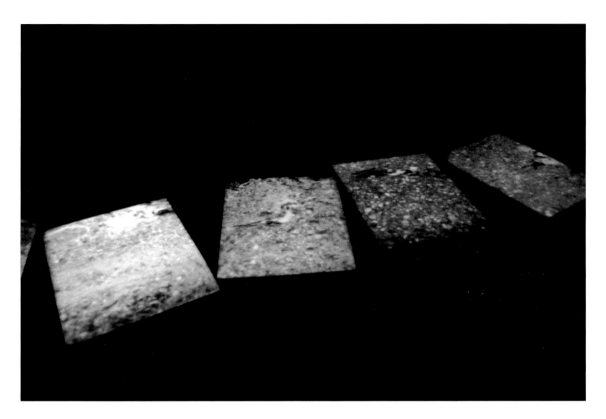

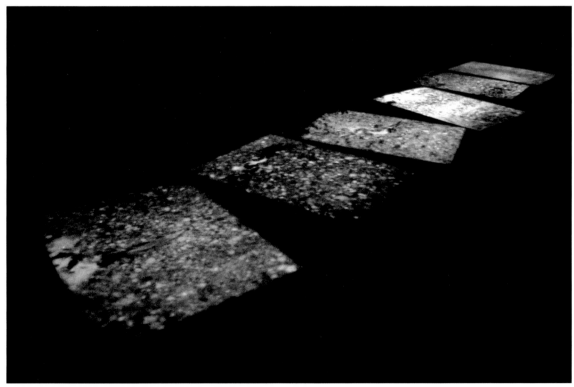

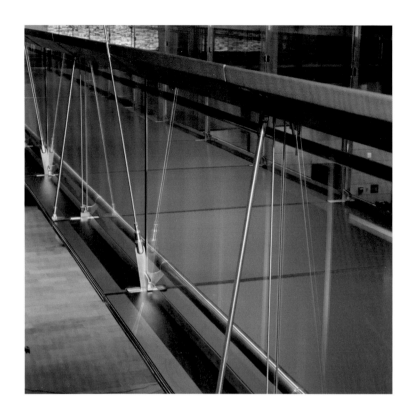

Luminous Blue Glass Bridge, Seattle, Washington, 2001–2003; *above*: the handrail and foot rest are both part of the bridge's structural system; *right*: view of the bridge spanning the atrium; *facing page*: the cobalt glass deck suggests a connection of the bridge to the Puget Sound

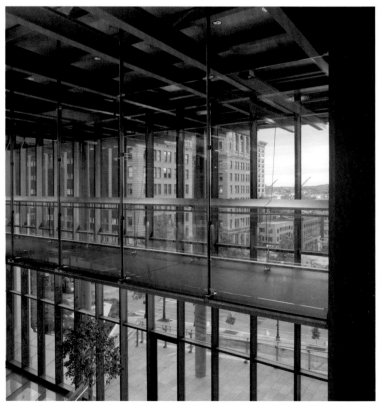

Luminous Blue Glass Bridge, Seattle, Washington, 2001–2003; views of the bridge spanning the atrium; the handrail is large enough to lean on and observe the view of the Puget Sound.

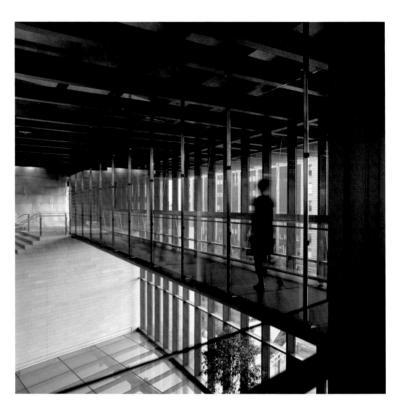

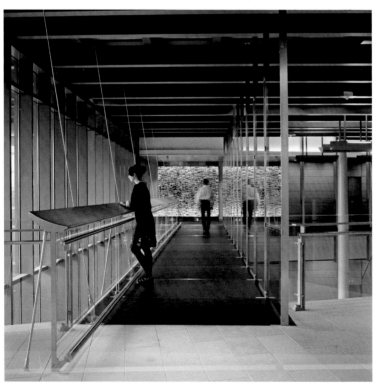

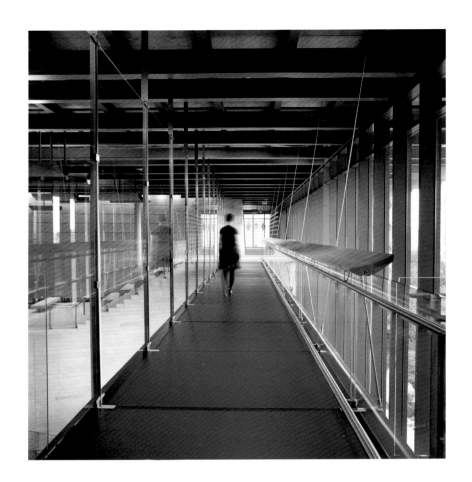

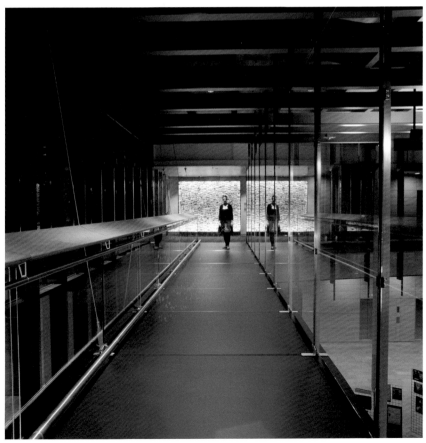

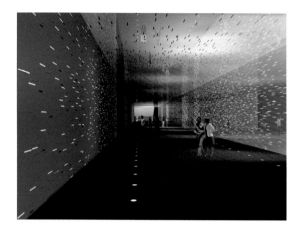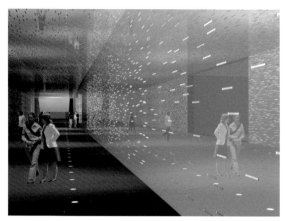

Dey Street Passage, New York City, 2004;
above: renderings of interactive lighting levels

More recent projects do not merely relate back to Carpenter's film installations; instead, they incorporate filmic devices within the glass projects themselves, employing technology to suspend reality. In these more recent projects, unlike Carpenter's earliest installations, the technological devices are less visible than their effects. Conceived in 2004 as part of the Fulton Street Transit Center but not, unfortunately, executed, the *Dey Street Passage* project proposed a pedestrian link between Fulton Street and the World Trade Center subway stations. Carpenter's project consisted of highly reflective surfaces—a black terrazzo floor with stainless steel bar inserts, and a glossy, opaque glass wall and ceiling. The final surface, one of the long side walls of the passageway, was envisioned as a polished stainless steel surface perforated with thin horizontal rectangles that would emit light through LED sources integrated into this wall that would reflect off of the glossy opposite wall and ceiling.

Activated by pedestrian movement, speeds, and densities, this interactive wall of luminous slits would have bounced light off of the tunnel's other surfaces, creating a dynamic, glowing galaxy. In another installation, *Reflection Passage* (2003–2006), in the Museum of Jewish Heritage at Battery Park City, the tie to Carpenter's earlier work is even more overt. As in *Orientation, Vortex,* and *Shaking,* the Museum of Jewish Heritage project mechanically manipulates nature to dislocate but not disrupt nature. The project consists of a "light work" on marking the link between the museum's two buildings. The link permits a spectacular view of New York Harbor; Carpenter's installation occupies a white box within the link that gently turns its back on that direct view of the harbor by offering instead a constructed, evocative view. A 12-foot × 6-foot acid-etched glass screen

Dey Street Passage, New York City, 2004;
above: cross section of Fulton Street Transit
Center showing underground tunnel; *below*:
early study model shows the intent of using
rear-lit punched stainless-steel wall surfaces

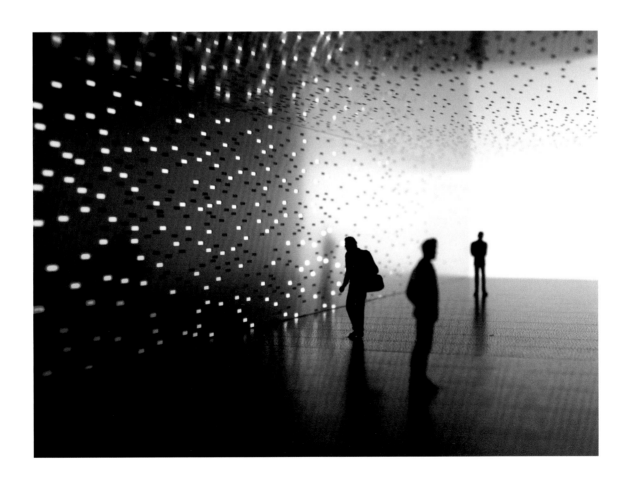

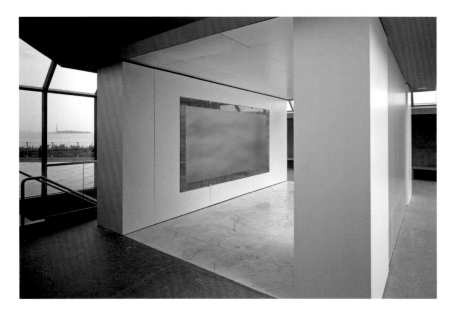

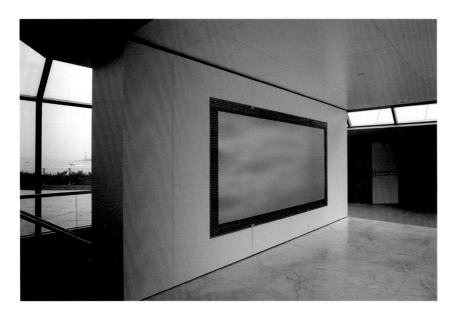

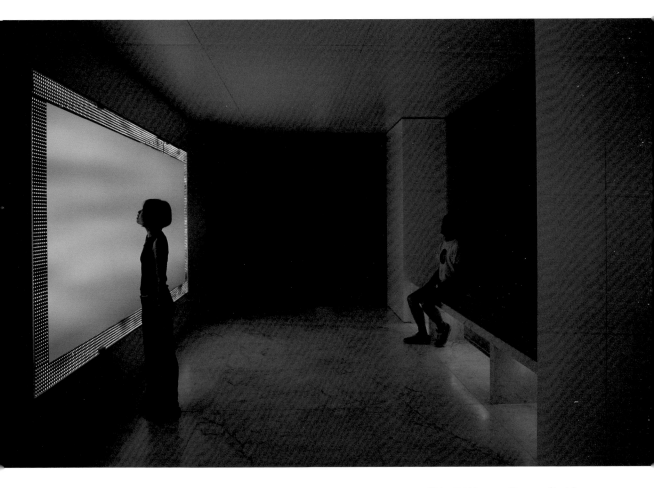

Water Light Passage, **Museum of Jewish Heritage, New York City, 2003–2006;** *above*: view at night of the passage illuminated by the river's transposed light; *facing page, top to bottom*: the etched glass reconstitutes the LED pixels into a luminous image; the LEDs and etched-glass panel is at the threshold to the museum's expanded galleries; a computer-controlled videocamera mounted on the museum's exterior provides a live feed of the brightest part of the river that is displayed by the LED wall.

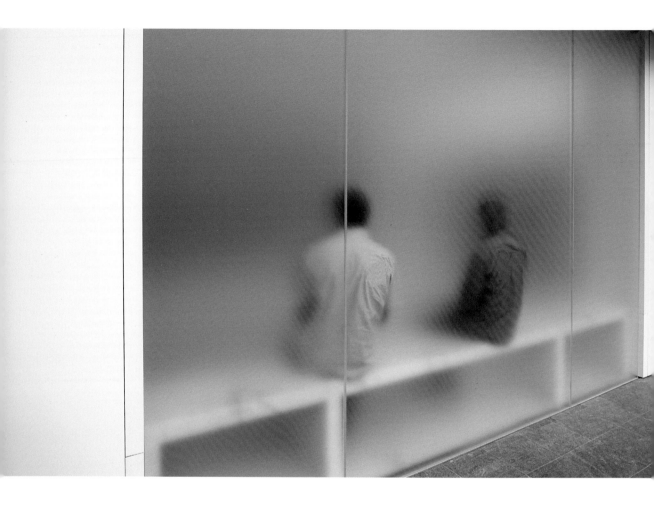

displays an image that is a manipulated feed from a programmable video camera mounted on the building's rooftop that tracks the brightest sunlight or moonlight reflections at any given moment on the harbor's water surface. LED diodes then pixilate and reconstitute this view onto the screen in the gallery box.

The result is an ever-changing luminous surface that evokes but does not represent the harbor view. It is framed and focused in such a way as to draw the viewer's attention to views of the water that would never otherwise be noticed. In both of these projects, the dreamlike dislocation of reality is as shared as it is individualized. One could stand still in the *Dey Street Passage*, but movement of others would still affect the lighting. And although one could stand alone in the Jewish Museum installation, the

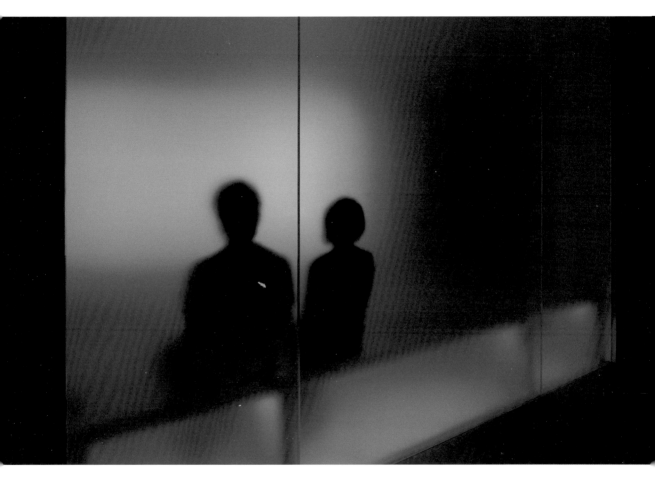

Water Light Passage, **Museum of Jewish Heritage,
New York City, 2003–2006;** *above*: view at night into
the passage; *facing page*: view during the day into
the passage, seen through its glass wall panels

project dimensions suggest that the optimum audience is about two to four people. Those standing near the screen turn into dark, flattened silhouettes across the image for those seated on the stone bench. And those who are seated, leaning against the back wall, subsequently become part of the installation as well; their backs pressed against the frosted glass wall become clearly visible, while their heads, like the bluish glow of the screen itself, takes on a shadowy glow through the translucent surface. The ideal view of this installation would not be seeing it all alone but, rather, seeing it change as different groups occupy it. If birds, snakes, and fish were the protagonists of Carpenter's early work, human beings now occupy that role.

This public component of Carpenter's project coincides with the increasing scale and complexity of his commissions in recent years. For the extension to the Israel Museum in Jerusalem (2005–2010), Carpenter is reworking the entry sequence, orientation, and circulation, while also constructing more than 80,000 square feet of new gallery space. The forty-year-old original museum, designed by Alfred Mansfeld, consists of a series of interconnected, terraced modules that resemble a Mediterranean hill town. Carpenter's project adds several new pavilions, especially at the entry where three simple structures serve entry/ticketing, retail, and information/events/food, as well as a new circulation spine that helps to transform the 20-acre campus into a site that more effectively capitalizes on its outdoor environments and atmospheres. Carpenter's new pavilions—lanterns of transparency and translucency—transform and unify the campus. The new below-grade circulation passage between the entry and the main museum, like the *Dey Street Passage,* draws users' attention laterally. Where the *Dey Street Passage* did so with artificial LED lighting behind the perforated stainless-steel screen, here Carpenter divides the primary lateral wall into a series of vertical scrims, transforming the lateral surface into space. Transparent glass, translucent glass, planted walls, and openings create a linear garden alongside the circulation space. Light passing through the cast glass and water animates this space that is below ground. While Carpenter collaborated on this project with the Israeli firm Efrat-Kowalsky Architects, JCDA was the lead design office—a notable shift from his previous collaborations, which tended to be isolated projects

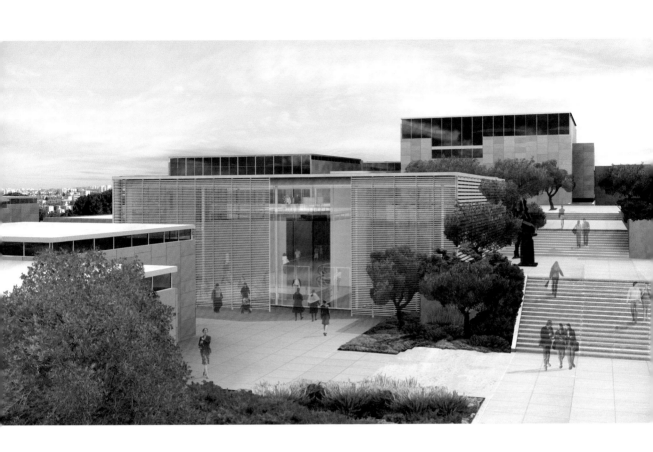

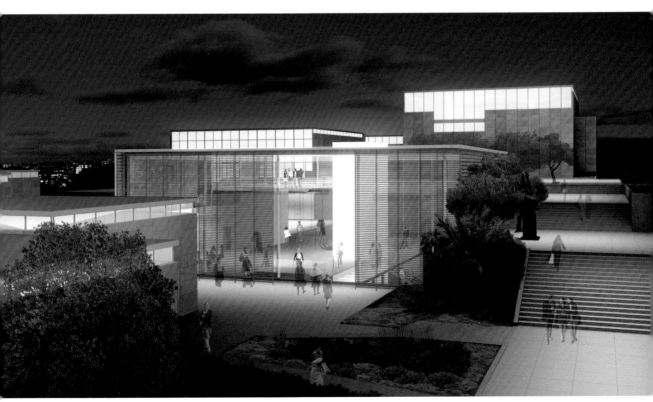

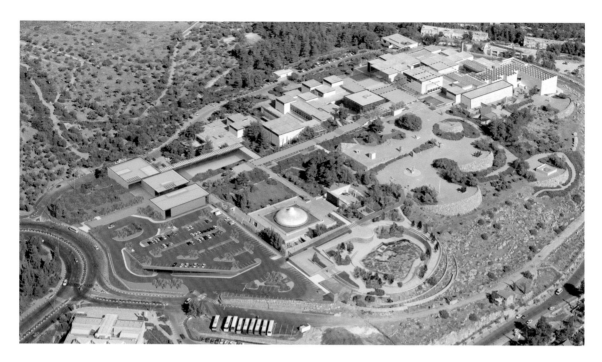

Israel Museum, Jerusalem, 2005–2010;
above: aerial view of the Israel Museum
campus, highlighting the conceptual layout
for the new main entry, route of passage, and
gallery entrance pavilion; *below*: daytime view
of new main entry showing information/food
services/events pavilion (far left), ticketing/
security pavilion (left), retail pavilion (right),
and the Shrine of the Book (far right)

within other architects' buildings. The museum's large scale offered an opportunity for Carpenter to create not just a moment that provides an escape from reality but a series of interconnected moments that construct a complex parallel reality.

In 1914, when glass was still a novel material, the German writer Paul Scheerbart wrote a novel on glass. He also wrote a manifesto, *Glasarchitektur*, with 111 points, ranging from the mundane to the fantastic. Scheerbart's penultimate point turns to the importance of science in constructing the material's magical effects: "We are not at the end of a cultural period—but at the beginning. We still have extraordinary marvels to expect from technics and chemistry, which should not be forgotten. This ought to give us constant encouragement."[14] As Detlef Mertins has noted, Scheerbart's mixture of the rationality of technology and the enchantment of art was aimed at a utopian premodern community "not by rejecting technology but by (re)turning to nature through the most advanced building science and technology."[15] Almost 100 years later, Carpenter's own mixture of the rationality of technology and the enchantment of art is not directed at such a utopia, a nonplace, but instead offers a place to the side of everyday reality or entirely individualized dreams. While this sensational-topia does not harbor the political ambitions of the members of the early twentieth-century expressionist Glass Chain (Taut, Gropius, Scharoun, and others), it offers a different kind of politics through the unforeseeable effects that rendering light material can have on an audience. With Carpenter's turn to more public projects, this effect is becoming ever more powerful. Beyond surface appeal, Carpenter's dexterous manipulation of glass constructs a space of possibility that constantly surprises while constantly returning to his initial theme of making visible the natural forces that surround us.

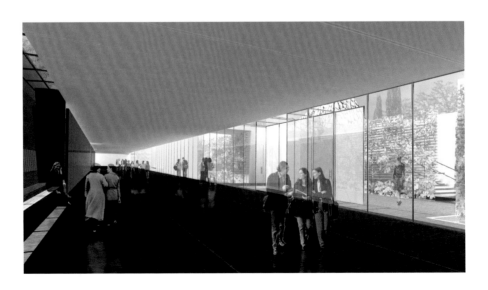

Israel Museum, Jerusalem, 2005–2010;
facing page, top to bottom: interior view of the
gallery entrance pavilion providing access to
the museum's gallery wings, auditorium, and
new temporary exhibition spaces; interior
view of the gallery entrance pavilion; view
looking south inside the Route of Passage
beneath Carter Promenade

NOTES

1. As referenced in Jose Quetglas, "Fear of Glass: The Barcelona Pavilion," in Beatriz Colomina, ed., *Architecture-production* (New York: Princeton Architectural Press), p. 141.

2. *De insomniis* 1.459a8-10, as cited in Daniel Heller-Roazen, *The Inner Touch: Archaeology of a Sensation* (Cambridge, MA: MIT/Zone Books, 2007), p. 70.

3. Aristotle, as cited in ibid.

4. Aristotle, *De somno et vigilia* 2.456a26, as cited in ibid.

5. Ibid.

6. Ibid., p. 71.

7. Nancy Fraser, "Rethinking the Public Sphere: A Contribution to the Critique of Actually Existing Democracy" in *Habermas and the Public Sphere*, edited by Craig Calhoun (Cambridge, MA: MIT Press, 1992), pp. 109–142.

8. James Carpenter, "Vortex," Art Park, Lewiston, New York, 1978; citation from JCDA firm booklet, 2005.

9. Ibid.

10. Pia Sarpaneva, "Interview with James Carpenter," *Presence Symposium* (Blacksburg, VA: College of Architecture and Urban Studies of Virginia Tech, 1998), p. 5.

11. Steven Holl, "Phenomena and Idea," in *GA Architect # 11 Steven Holl*, edited by Yukio Futagawa (Tokyo: A.D.A. Editz, 1993), p. 12.

12. James Carpenter, as quoted in Christian Schittich, "New Glass Architecture—Not Just Built Transparency," *Details* 2000 (3): 345.

13. James Carpenter WAM interview with Bruce Danzinger, November 11, 1996: 7.

14. Paul Scheerbart, *Glass Architecture*, translated by Dennis Sharp (New York: Praeger, 1972), p. 73.

15. Detlef Mertins, "The Enticing and Threatening Face of Prehistory: Walter Benjamin and the Utopia of Glass," *Assemblage* 29 (April 1996): 11.

Although it may seem counterintuitive, James Carpenter's work offers the best caption to—rather than illustration of—Paul Valéry's famous observation that "seeing is forgetting the name of what one sees." Any one of Carpenter's projects elucidates Valéry's claim. Walking through these projects, one immediately understands how it's possible to hover in a suspended state between seeing and understanding, between an initial, unknowing perception and a final, knowing classification. This hovering pause, which in Carpenter's work can last a very long time, is neither the moment of being simply wowed by the magician's hand nor the moment of learning his secret—instead, it lingers between the two.

But how to convey this moment of suspension, when seeing obscures that which one sees? How does one depict the ineffable? Optical diagrams are a problematic convention in architecture, because their exactitude relies on an abstraction (isolated optical lines traveling through white space) that competes with that of architectural drawing (orthographic lines representing built space). Photographs, perspectives, and renderings suggest the effect of Carpenter's work, but without offering technical explications. Their singularity doesn't convey the lingering suspension between incomprehension and comprehension, and their depicted ambiance overwhelms technical information.

The following section features diagrams by Lucia Allais, commissioned especially for this book. **These diagrams are intended to mitigate this conflict between the optical diagram and the architectural drawing.** They convey both architectural representation (scale, enclosure, and form) and optical effect (depth, opacity, and reflection) to depict Carpenter's project: the information—that which lies between experience and detail—that is captured by the glass itself.

The project diagrams separate that captured information into four layers: optics, pattern, detail, and movement. The film diagrams, which convey the simultaneous information of the film, the projections included within the film, the making of the film, and the plan diagram of the film, are similarly separated into four views: optics, projected sections, filmed sections, and projected plans. By limiting the palette to blues and whites, gradients and lines, the diagrams underscore the overlaps that exist across these four layers and views. —s.w.

LICHTHOF

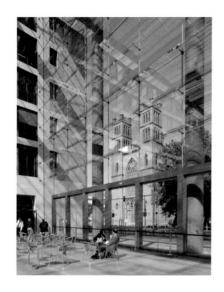

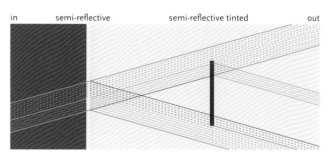

in semi-reflective semi-reflective tinted out

OPTICAL SECTION ········· sunlight

ELEVATION PATTERN

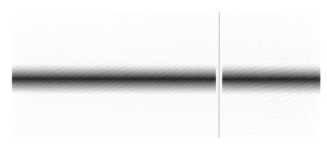

DETAIL ELEVATION

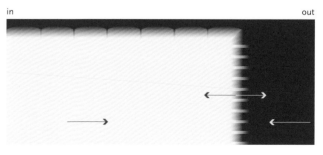

in out

MOVEMENT SECTION ⟶ viewer

RETRACTING SCREEN

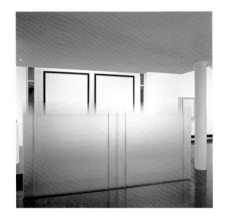

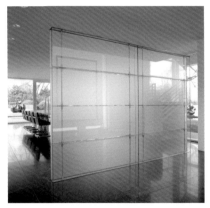

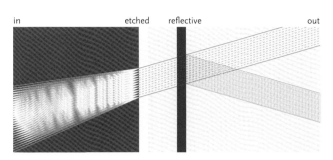

OPTICAL SECTION ········· sunlight

ELEVATION PATTERN

DETAIL ELEVATION

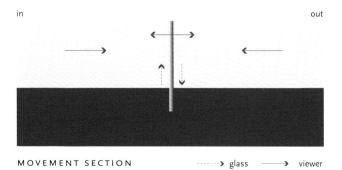

MOVEMENT SECTION ····▸ glass ——▸ viewer

PERISCOPE WINDOW

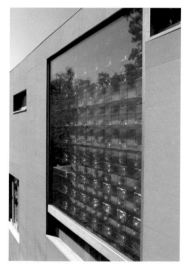

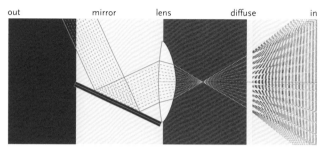

OPTICAL SECTION sunlight

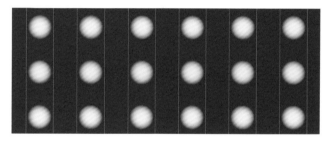

ELEVATION PATTERN

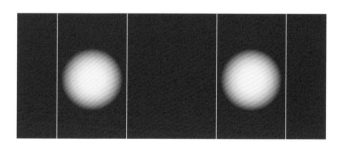

DETAIL ELEVATION

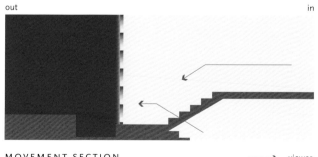

MOVEMENT SECTION → viewer

DICHROIC LIGHT FIELD

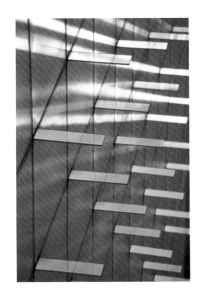

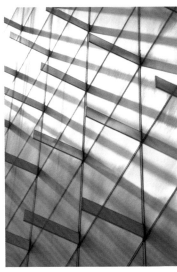

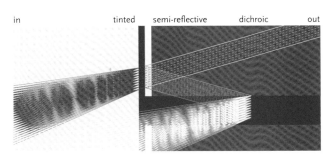

in tinted semi-reflective dichroic out

OPTICAL SECTION ------- sunlight

ELEVATION PATTERN

ELEVATION DETAIL

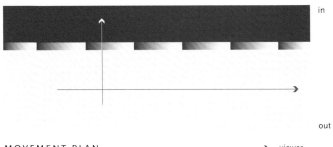

in

out

MOVEMENT PLAN ———→ viewer

GLASS TUBE FIELD

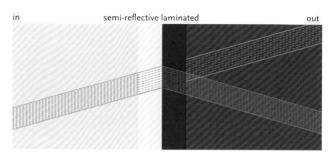

in semi-reflective laminated out

OPTICAL SECTION sunlight

ELEVATION PATTERN

DETAIL ELEVATION

in

out

MOVEMENT SECTION ⟶ viewer

LUMINOUS GLASS BRIDGE

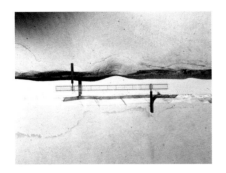

OPTICAL SECTION 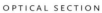 sunlight

PATTERN PLAN

DETAIL PLAN

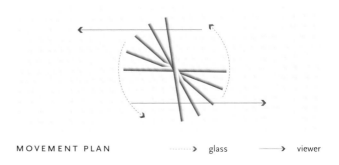

MOVEMENT PLAN ·······> glass ——> viewer

MOIRÉ STAIR TOWER

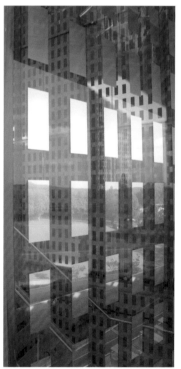

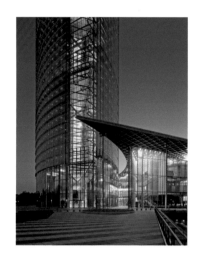

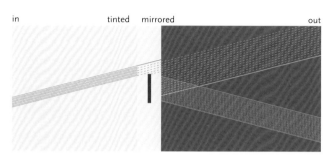

in tinted mirrored out

OPTICAL SECTION -------- sunlight

ELEVATION PATTERN

DETAIL ELEVATION

out in out

MOVEMENT PLAN ⟶ viewer

LUMINOUS THRESHOLD

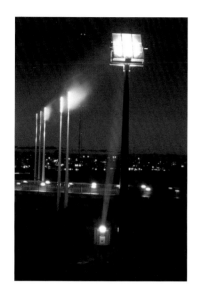

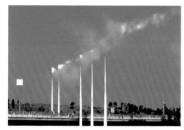

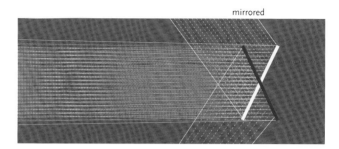

OPTICAL SECTION

mirrored

·········· sunlight

ELEVATION PATTERN

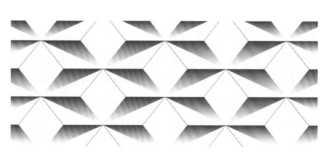

DETAIL ELEVATION

MOVEMENT PLAN

·········> smoke ⎯⎯⎯> viewer

ISRAEL MUSEUM

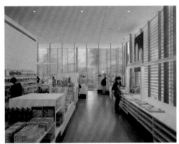

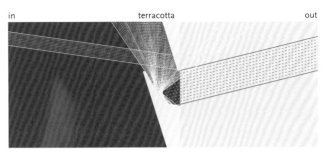

in terracotta out

SCREEN SECTION - - - - - - - - sunlight

ELEVATION PATTERN, EAST-WEST

ELEVATION PATTERN, NORTH-SOUTH

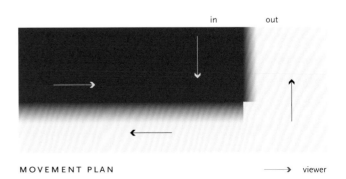

in out

MOVEMENT PLAN ⟶ viewer

MIGRATION

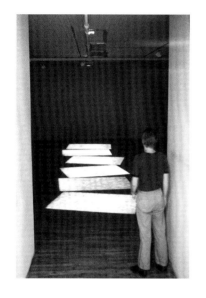

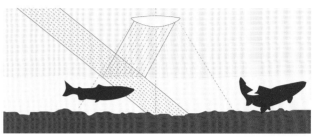

FILMED SECTION —— sun ray ------- camera field

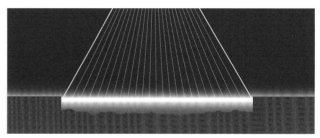

PROJECTED SECTION projector field

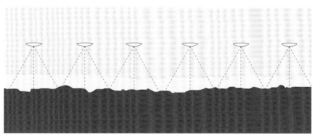

FILMED SECTION ------- camera field

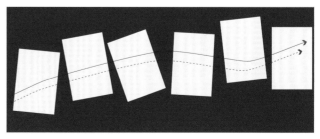

PROJECTED PLAN ------> fish path ——> viewer path

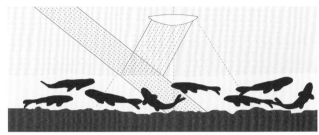

FILMED SECTION ——— sun ray ------- camera field

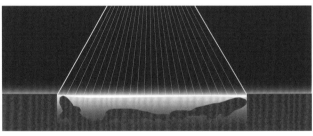

PROJECTED DETAIL ▬▬ projector field

FILMED SECTION ------- camera field

PROJECTED PLAN ------▶ fish path ———▶ viewer path

CAUSE

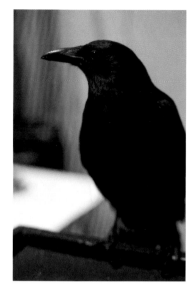

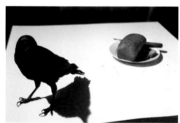

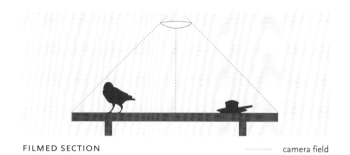

FILMED SECTION ----- camera field

PROJECTED SECTION ▬▬ projector field

FILMED SECTION ----- camera field

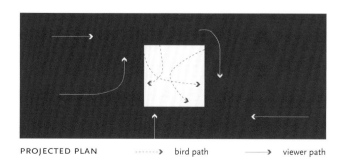

PROJECTED PLAN ----→ bird path ——→ viewer path

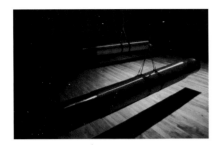

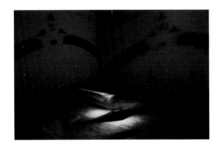

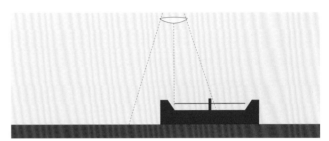

FILMED SECTION ---------- camera field

PROJECTED SECTION ▬▬ projector field

INSTALLED SECTION ▬▬ electric current

PROJECTED PLAN ------▶ magnet path ——▶ viewer path

LUCIA ALLAIS is Assistant Professor of Architecture at Princeton University.

MARK LINDER is Associate Professor of Architecture and Chancellor's Fellow in the Humanities at Syracuse University.

JORGE SILVETTI is the Nelson Robinson Jr. Professor of Architecture at the Harvard University Graduate School of Design.

SARAH WHITING is Dean and William Ward Watkin Professor of Architecture at the Rice University School of Architecture. Whiting is also a design partner of ww, an architectural firm based in Houston, Texas. Whiting's writing has been published widely in magazines and anthologies, and she is the founding editor of an architecture book series with Princeton University Press, entitled *POINT*.

Confines 1975
Conception, installation, production: James Carpenter
Camera work, installation: Dan Reiser, Thomas Paine

Cause 1975–1976
Conception, installation, production: James Carpenter
Camera work, installation: Dan Reiser, Thomas Paine

Migration 1978
Conception, installation, production: James Carpenter
Camera work: Buster Simpson
Installation: Dan Reiser

Luminous Glass Bridge 1987
James Carpenter Design Associates Inc., proposal
Marin County, California
Client: Private
Structural engineer: Ove Arup & Partners

Lichthof 1997–1999
German Foreign Ministry, Berlin, Germany
James Carpenter Design Associates Inc.
Client: Federal Office for Construction and Regional
Planning, Germany
Architect: Müller Reimann Architekten, Berlin
Engineer: Schlaich Bergermann and Partners, Stuttgart,
Prof. Schlaich, Dr. Schober, Thomas Fackler
Climate engineering: Transsolar, Stuttgart

Luminous Blue Glass Bridge 2001–2003
Seattle, Washington
James Carpenter Design Associates Inc.
Client: City of Seattle, Seattle City Hall
Architect: Bohlin, Cywinsky, Jackson Architects
Structural engineer: Dewhurst Macfarlane

Double Cable-Net Wall 1999–2004
Time Warner Building
Jazz@Lincoln Center, New York
James Carpenter Design Associates Inc.
Architect: Skidmore, Owings & Merrill, New York, New York
SOM design principal: David Childs
SOM associate designer: Jeff Holmes
Structural engineer: Schlaich Bergermann and Partners
Client: The Related Companies, Columbus Center LLC
Glass wall contractor: W&W Glass Systems

Dey Street Passage 2004
New York
James Carpenter Design Associates Inc.
Client: MTA Arts in Transit and the City of New York
Department of Design and Construction
Architect: Grimshaw Architects
Interactivity: Kinecity

7 World Trade Center 2003–2006
Curtain Wall, Podium Screen, New York
James Carpenter Design Associates Inc.
Client: Silverstein Properties
Architect: Skidmore, Owings & Merrill, New York, New York
SOM design principal: David Childs
SOM technical principal: Carl Galioto
SOM associate partner: Peter Ruggiero
SOM team: Chris Cooper, Ken Lewis, Nick Holt,
Christopher Olson

Podium wall
Interactive LED consultant: Kinecity Inc., Marek Walczak

Curtain wall
Daylight consultant: Carpenter Norris Consulting,
Davidson Norris

Cable-net entry
Structural engineer: Schlaich Bergermann and Partners,
Dr. Hans Schober, Stefan Justis

Lobby wall
Collaborative artwork with Jenny Holzer
Structural engineer: SOM Engineering, William Baker,
Shane McCormick

Water Light Passage 2003–2006
Museum of Jewish Heritage, New York, New York
James Carpenter Design Associates Inc.
Client: Museum of Jewish Heritage, New York, New York
Interactive consultant: Kinecity
LED: LED Effects

Israel Museum 2005–2010
Jerusalem, Israel
James Carpenter Design Associates Inc.
Executive architect: Lerman Architects, Tel Aviv
Planning architect: Efrat-Kowalsky Architects